CORBY & ROCKINGHAM FOREST
THROUGH TIME

Peter Hill

AMBERLEY PUBLISHING

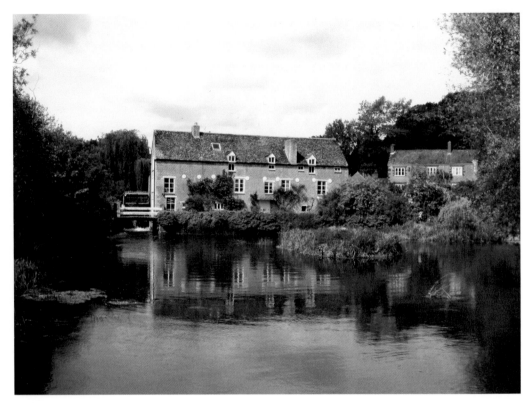

Wadenhoe Mill

First published 2009

Amberley Publishing Plc
Cirencester Road, Chalford,
Stroud, Gloucestershire, GL6 8PE

www.amberley-books.com

British Library Cataloguing in Publication Data.
A catalogue record for this book is available from the British Library.

ISBN 978 1 84868 641 1

Typesetting and Origination by Amberley Publishing.
Printed in Great Britain.

Introduction

All towns and villages in England have undergone changes over the years, some more devastating than others. If a list was to be compiled for those settlements that have virtually been transformed beyond recognition, then the old village of Corby would surely be at the top – such has been the scale of visual change since demolition took place from the end of 1958 to 1962, virtually wiping it off the map, as the new steel town of Corby expanded outwards, necessitating a new network of roads and a massive house construction programme. And now the adjacent modern town of Corby itself is undergoing a metamorphosis like its older sister, albeit in not such a drastic manner, with new state-of-the-art buildings replacing those that were constructed during the 1950s, '60s and '70s.

Elsewhere, apart from neighbouring Kettering, the contrast could not be more apparent with the other towns and villages that make up the area known as the Rockingham Forest. They remain virtually intact with only additional small-scale building or almost like-for-like replacement having taken place, using identical local materials which the area is blessed with – golden honey coloured ironstone, creamy more durable limestone, and a fissile form of the latter known as Collyweston slate.

They are not entirely frozen in time however, for like everywhere else in Britain, they have been subject to demographic changes that have occurred in the latter part of the last century and continue today. Younger members of long-established families have been forced to move away from their villages, unable to pay the premium prices that such desirable housing and surroundings demand, and which only more affluent outsiders can afford.
In addition, many of the villages have lost their social centres – the local shop unable to compete with local supermarkets, the post office, and the village pub(s) have closed; and five churches have become redundant, as a result of shrinking congregations.

Yet, increasing numbers of visitors are drawn to the beauty, tranquillity and timelessness of the Forest area, as are film and television companies who make use of its fine locations, stately homes (such as Rockingham Castle, Deene Park, Kirby Hall, Burghley House), and beautiful, undulating landscape with countless streams, quiet lanes and cross-country footpaths and large pockets of woodland.

Notable events in the nation's history have occurred within its boundaries: Richard III was born at Fotheringhay, a home of the York family, and where later, Mary Queen of Scots was tried and beheaded. Francis Tresham, whose family seat was at Rushton, was connected with the conspirators in the Gunpowder Plot and 'gave the game away', and

Sir Edward Montagu of Boughton House, a high ranking official in the government was responsible for 5 November being instituted as an annual celebration, initially as a day of thanksgiving in church.

It must be mentioned here that the word 'forest' does not mean extensive woodland; this is only one definition. Royal forests were created by William I after the conquest of England, when he sent commissioners around his new realm to mark out areas for hunting – his favourite pastime. This land was subsequently placed under a special set of regulations, known as Forest Law, which stipulated that only the King could hunt certain beasts (deer and boar) and to protect woodland where it existed. A hierarchy of officials was set up to ensure these laws were adhered to, and that wrongdoers were brought to justice. This practice was continued by successive monarchs until the seventeenth century.

The original Rockingham Forest stretched all the way from Stamford in the north, to Northampton in the south. However, it declined in size over subsequent centuries when large areas were disafforested (freed from Forest Law) and sold off by the Crown. Today's Rockingham Forest comprises the 'gateway' towns of Stamford, Oundle, Thrapston, Market Harborough and Kettering and 55 villages within its boundaries. These modern boundaries have been fixed partly using the River Nene to the east and the River Welland to the west, with a link road to the A14 in the south.

Let us now explore some of the Forest places within these pages and see how they have stood the test of time.

Peter Hill,
Spring 2009.

Acknowledgements

I would like to express my gratitude to the following individuals and organisations who loaned their treasured photographs from family albums or archives. Their generosity has enabled me to put together and complete this overall picture of the Forest area, and share those images with a wider audience: Kevin Abrahams, Brian Andrews, Ashley Village Archive, Cynthia Bagshaw, Alan Bates, Harold Beech, Quentin Bland, Tony Coales, Corby Borough Council, the late Frank Ellis, the late John and Gwen Hay, Carl Hector, Barry Hinton, Jill Johnson, Elizabeth Jordan of Gretton History Society, Bob Mears, John Measures, Pam Moore, Northampton Record Office, Oundle Museum, Chris Owen and Sue Hall, Tony Palenski, Jean Payne, Sue Payne, Alison Ramsay, Rockingham Forest Trust, Rothwell Heritage Centre, Bill and Beryl Simon of Brigstock History Society, Sheila and Mike Southwell, Marion Strange, Reg Sutton, Alan Toseland, Carew Treffarne, and Barbara Webb.

All attempts have been made to contact any other copyright holders and apologies are offered if any such ownership has not been acknowledged.

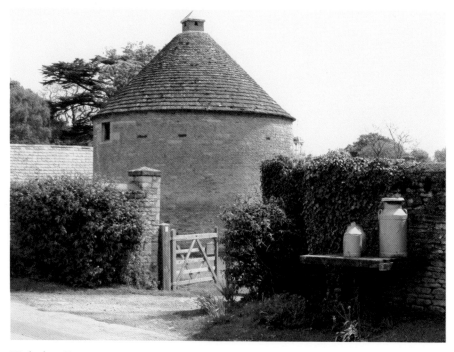

Wadenhoe Dovecote

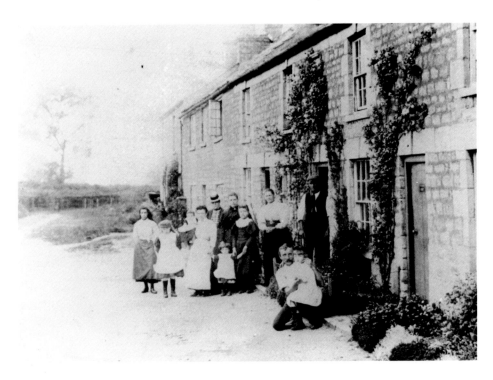

Davis Close, *c*.1902.
Originally known as Wade's Row, it was named after Widow Wade, wife of Thomas Wade, a stonemason from Weldon, who built the houses in 1855. It ran from the White Hart almost down to the railway bridge, and was demolished in 1961 as part of the village redevelopment programme. Members of the long-established Rowlatt family can be seen with their neighbours.

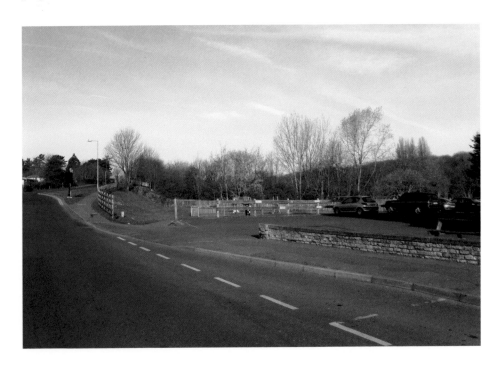

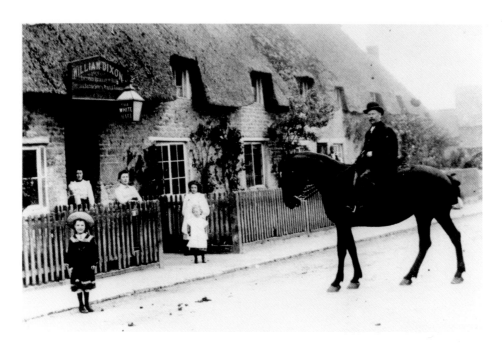

White Hart, 1892.

The pub was first recorded in 1847, when it was run by horse-dealer, John Burton, though it certainly existed before then, possibly as the Eight Bells, in 1820. Vine Cottage is visible at the end of the row. It was run by William and Flo Dixon, both seen here. The building was demolished in 1935, rebuilt in its present form and reopened in 1936.

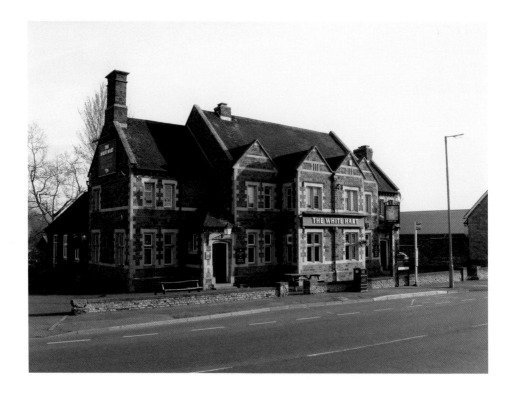

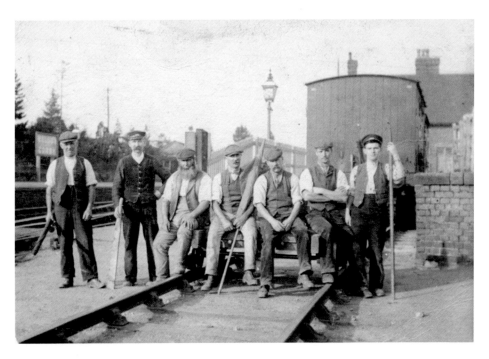

Corby Rail Station staff, 1907.

The original station was opened for goods in 1879, and for passenger traffic in March the following year. Initially known as 'Corby and Cottingham', it was changed to 'Weldon and Corby' in 1898, 'Corby and Weldon in 1937, and finally as 'Corby' in 1954 until its closure in 1966 (briefly reopening, 1987-1990). The new £3,000,000 station opened in February 2009.

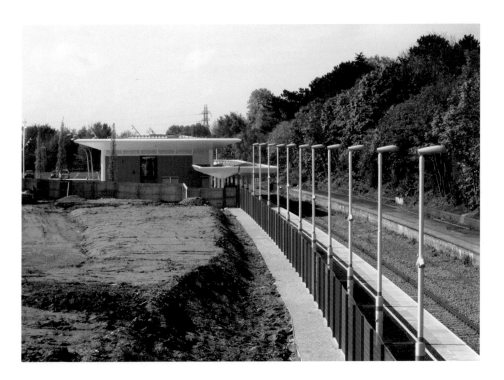

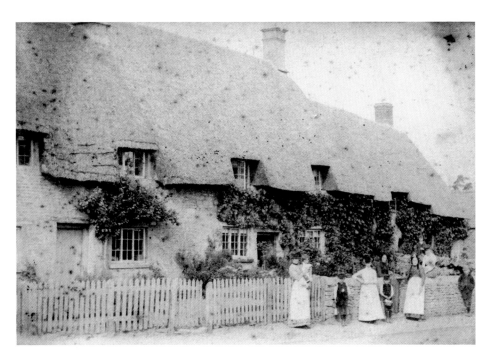

Vine Cottage, 1902.

Built *c.*1850 for members of the Rowlett family by a stonemason of the Streather family, to whom they were related, its later occupants included the Paynes, and Walter Walker, manager of the village Co-op, who tended a fine garden at the rear. Still surviving, it is a fitting symbol of the old village, as one enters the High Street coming from the station and town.

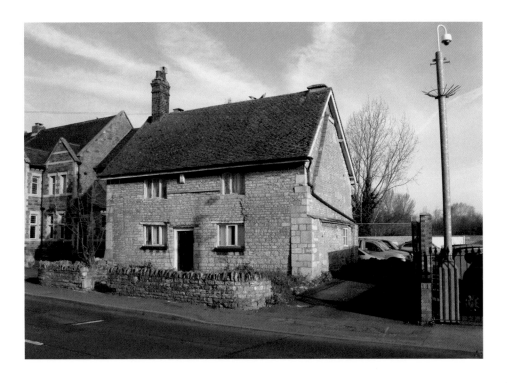

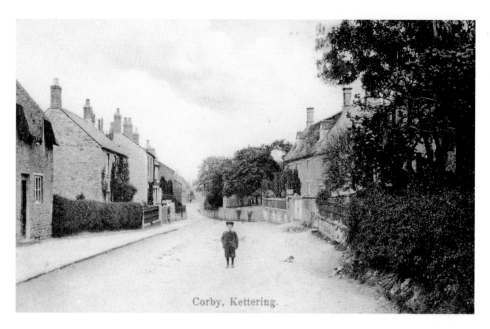

Corby, Kettering.

High Street, from Cottingham Road, *c*.1900.

The buildings on the right have since replaced by new housing, and part of the area on the left is now occupied by a car franchise, and a new village community centre. The boy would certainly not stand in the road today with the constant flow of traffic passing through!

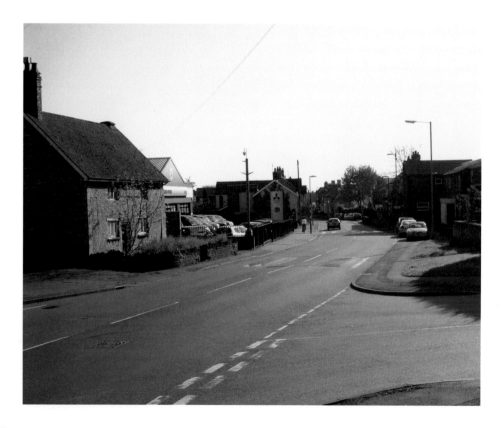

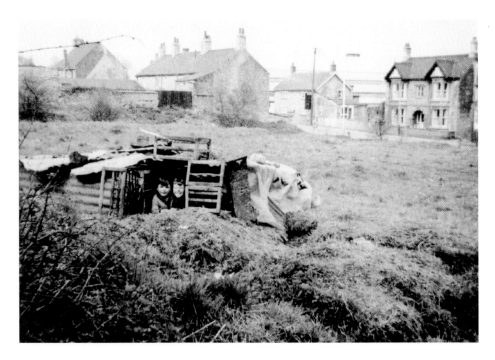

Off the High Street, *c.*1950s.
The two boys are playing on waste ground, now covered by modern housing, at the White Hart end of the High Street. The large house on the right of the picture is 'Bannigans', one-time home of the Streather family of stonemasons. Among its ornate features are Victorian ceramic wall tiles inside the arched porch, and sculptured figures above the central upper front window.

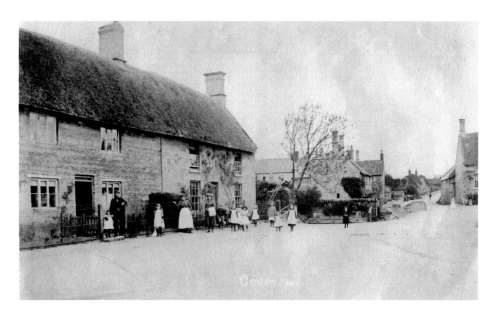

The Jamb, summer 1904.

Incredibly, all the buildings seen in this picture have disappeared, casualties of redevelopment in 1960/1. Members of the Payne and Patrick families are standing outside their homes on the left (now the site of the present village post office). Dag Lane, now Rockingham Road is beyond the bridge, with Tunwell Lane to the right. The village cattle pound stood behind the wall by the brook.

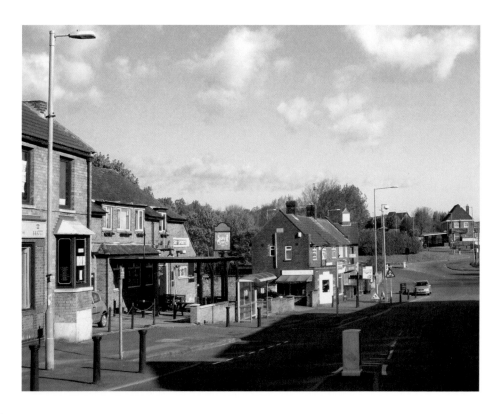

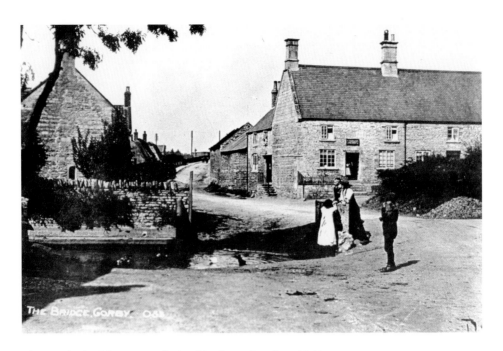

The Jamb, looking towards Rockingham Road, *c.*1919.

The street gets its name from the French 'jambe' meaning 'leg'. The other side of the bridge was known as Dag Lane, from an old word referring to the muck accumulating on the undersides of sheep from the surface; a similar name also occurred at Cottingham and Harringworth. The building on the right was that of Peerless, a shoemaker.

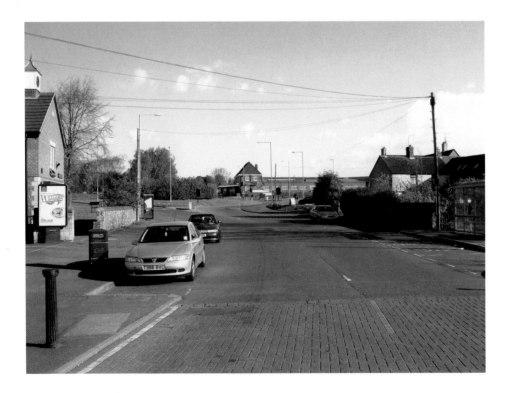

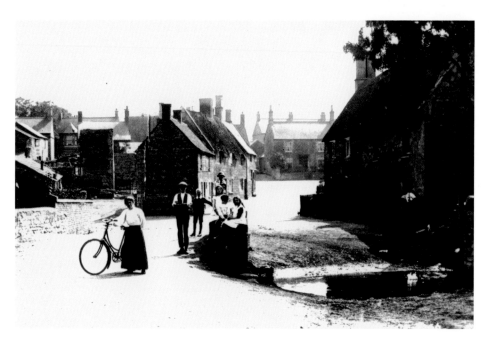

The Jamb looking towards the High Street, *c*.1919.
The bridge was replaced by a newer structure in 1960/1. Ducks and hens were a common sight in the vicinity which was a popular play area for children, all unthinkable today. The street leading off to the left is Chapel Lane. Among buildings running along the High Street are Bank House, facing the Jamb, and the rear premises of Boon's shoemaking business.

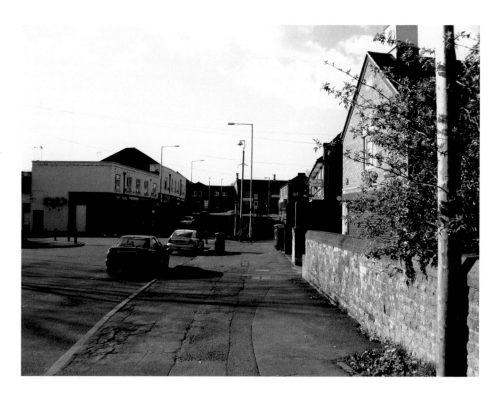

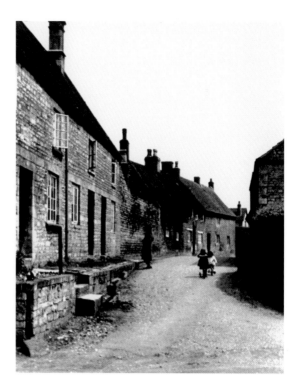

Tunwell Lane, from the Jamb, *c*.1950.
The Old White Horse pub can be seen on the left, just beyond the children. It was called the White Horse until *c*.1869 when it was renamed by Ann Clifford, landlady. It later moved to an adjoining site facing Lloyds Road, and is now the Village Inn, part of which can be seen behind the original building which is now a ladies' beauty salon.

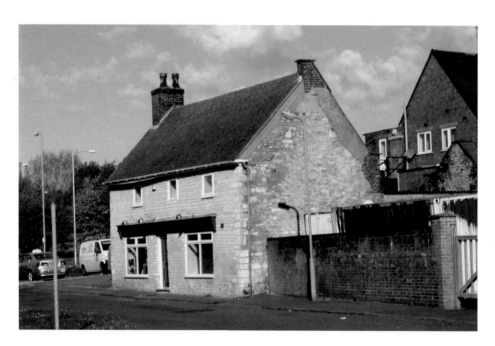

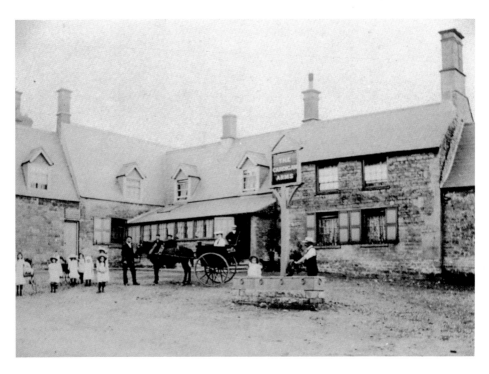

Cardigan Arms, the Jamb, *c*.1910.
The pub was first recorded in 1796, and was named after the manorial Brudenell family, based at nearby Deene. The area outside was a hive of activity, with a flourishing horse market at the front until the First World War (note the horse trough outside), whilst the rear was the site of the annual July fair. It was demolished and rebuilt in 1960.

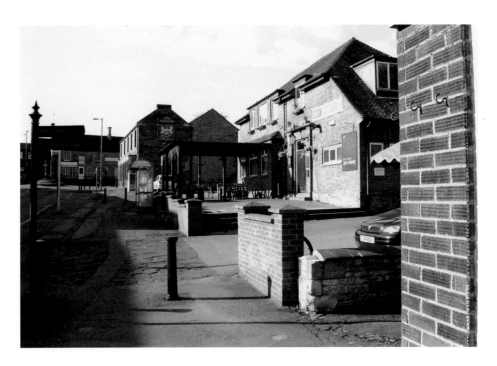

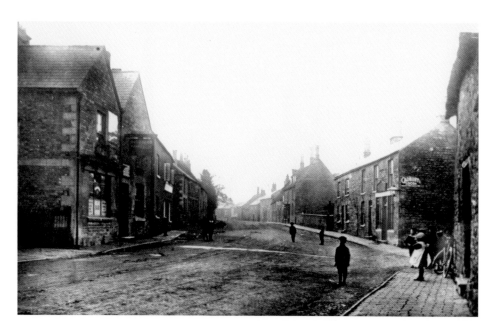

High Street, looking towards the Jamb, 1914.
The boy in the foreground is standing outside Manor Farm (1609), which later became associated with a garage, bank and telephone exchange, and is now earmarked to house the new Heritage Centre. The old Nag's Head pub stands on the left, whilst Stocks Lane leads off to the right. The tree on the right stands in front of Post Office Court.

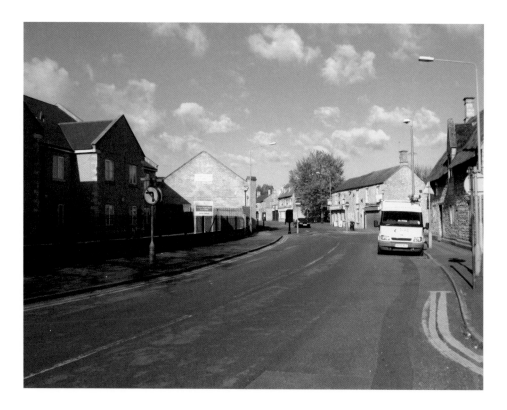

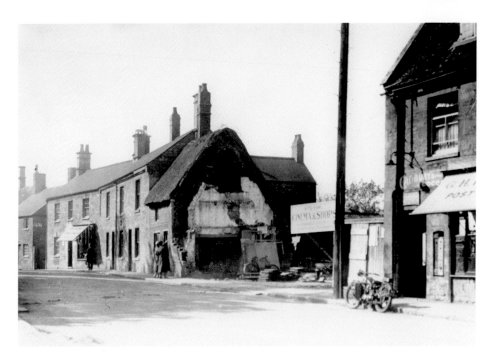

High Street, looking towards the Jamb, 1930s.

The original village post office can be seen on the right, run initially by the Chapman family, who had a candle making facility at the rear of the premises. A cinema was planned to occupy the space left by the partial demolition of two adjoining thatched cottages seen here, but the scheme never came to fruition.

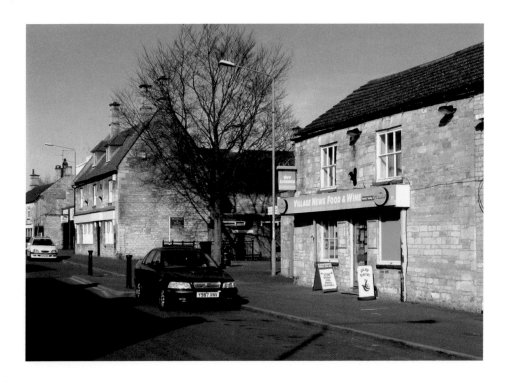

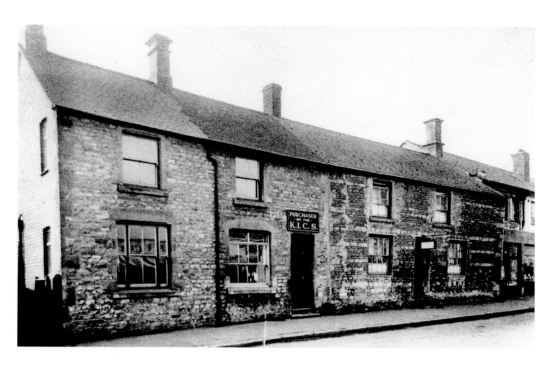

Kettering Industrial Co-operative Society, High Street, 1925.

The first branch of the Kettering Industrial Co-operative Society to open outside that town was in Corby village in 1898, trading in a converted house in the High Street. This was replaced by a larger premises, shown here in 1925. Two more branches were to open later: in Rockingham Road (1934) and Occupation Road, in 1936.

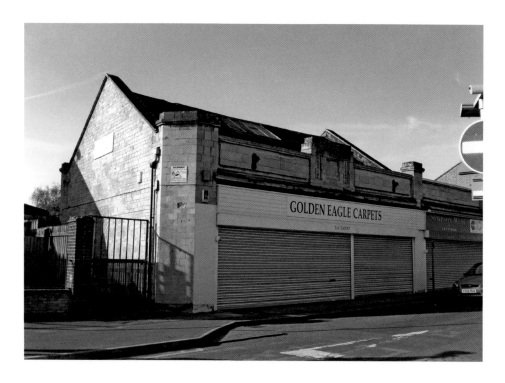

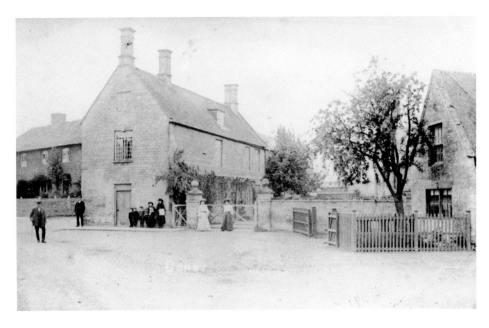

Entrance to Rowlett School, *c*.1910.

The original school was built here in 1834 by William Rowlett, a local man who became prosperous in the wool trade in Hampshire. The school was extended in 1881, rebuilt in 1914, and is now known as Corby Old Village Primary School. The school house to the left survives and is a much older building, dating from the eighteenth century, as is the adjoining former chapel.

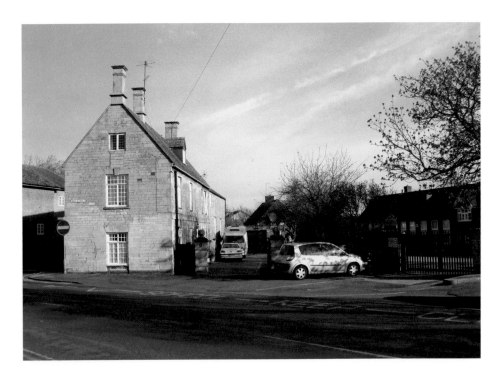

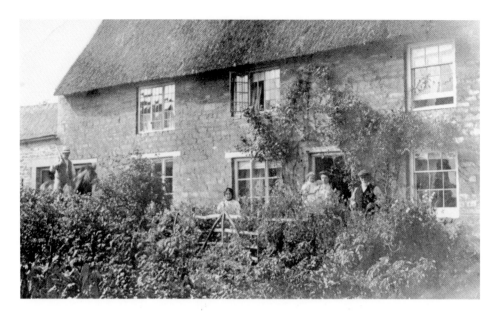

Farmhouse in Meeting Lane, *c*.1906.

There were originally six houses connected with farming, an occupation which has long since ceased in the village. This was the home of the long-established Colyer family, one of whom was the publican of the White Horse, *c*.1850. Rowland Colyer can be seen on horseback, with Clara his wife standing to his right. The building, which stood just past the old Congregational chapel, no longer exists.

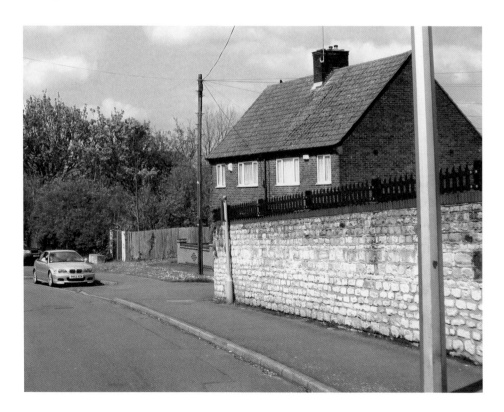

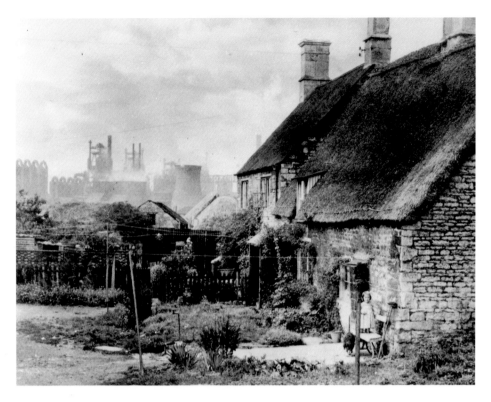

Meeting Lane, *c.*1934.
No other picture of the village captures the stark contrast between old and new Corby, as this scene in Meeting Lane. Features of the nascent steelworks form a backdrop to the simplicity of everyday domestic life in an old Forest village, which would never be the same again. The house stood at the junction with Tunwell Lane, close to the site where the newer photograph was taken.

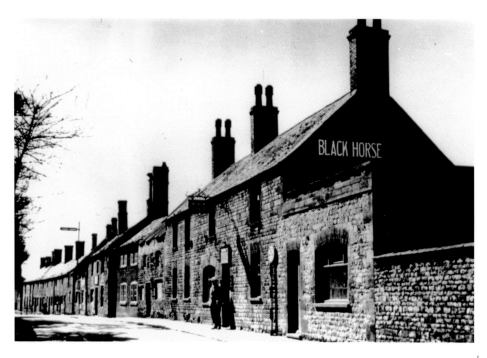

Black Horse, Church Street, *c.*1960.

Taken a short time before its demolition, along with the rest of the street, the pub was first recorded in 1796, with Mary Marshall as the landlady. Before the First World War, it was run by John Payne who had been landlord of the Nag's Head.

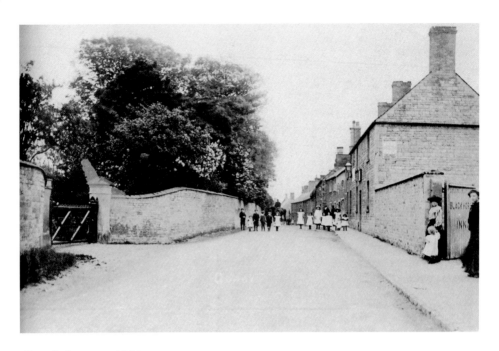

Church Street, *c.*1910.

A county poet, John Askham, wrote in the 1860s, 'The hand of change is on everything; it collars our old institutions and with the rudest grip shakes the life out of them ... so that we can hardly recognise them.' Today's view shows all the houses now gone, with the road realigned and renamed as part of the High Street, as it heads towards the dual carriageway.

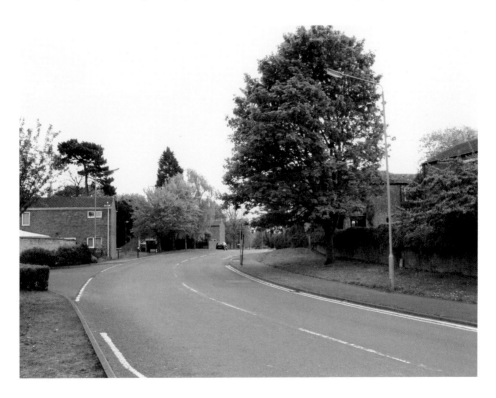

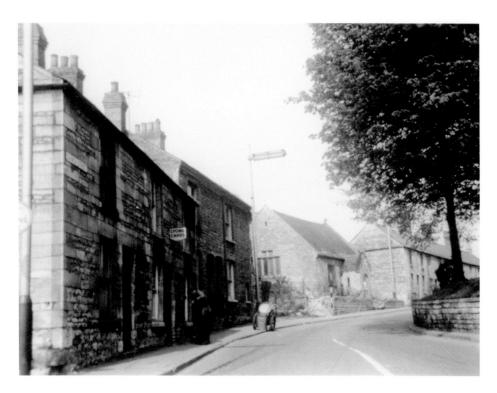

Church Street, looking towards the village, 1959.
This was how the street looked shortly before demolition began in October that year. The houses were so well built that the contractor from Finedon reported that each one took three days to demolish. Residents were compensated and moved into newer homes off South Road.

Church Corner, 1936.

Only modern homes and the dual carriageway now occupy the original site, which included Parliament House, and Church Cottages (the original eighteenth century almshouses). It was also known as Cookies Corner, from the name of the soft drinks available from a shop that stood there. The modern photo was taken on the opposite side of the road by the church porch.

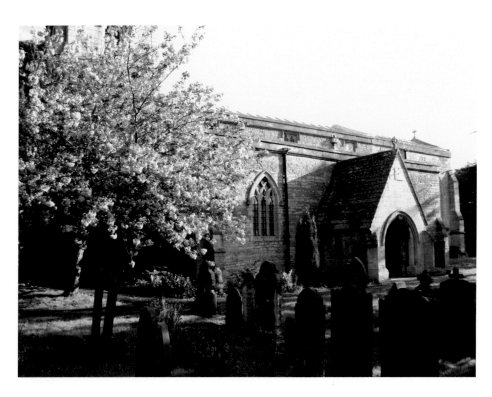

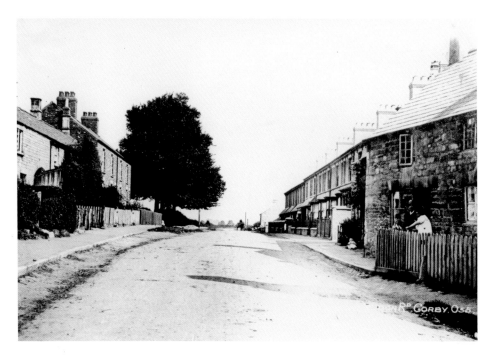

Weldon Road houses, *c.*1910.

In 1906, the Corby employer, James Pain, persuaded Geddington builder Tom Rippin to build six houses on Weldon Road. The rent was 12/6d. a week. Prospects were so good that he built another sixty on the same road, some of which still survive, as seen here. At the far end was a baker who cooked the families' Sunday roast for two-pence.

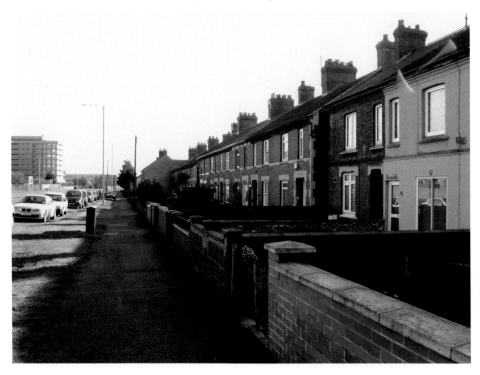

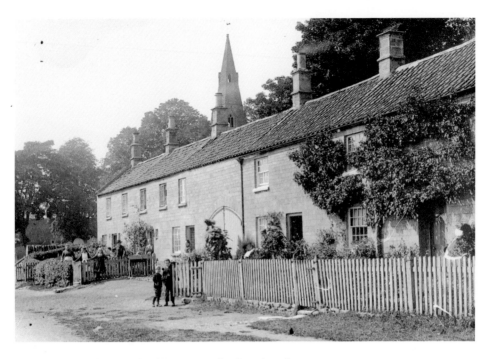

Weldon Road houses, looking towards the church, *c.*1898.
This scene is virtually unrecognisable today. All the buildings seen here were demolished in 1970 to make way for the roundabout, dual carriageway, and roads to Stanion and the steelworks (and now shopping centre). Even the houses behind the trees have since disappeared.

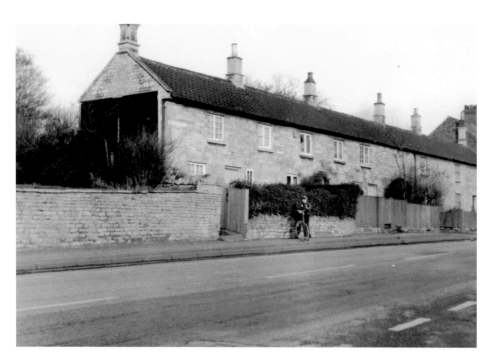

Weldon Road, 1904.

The road looking towards Weldon. The view today looks empty and sterile – in place of the houses are a builder's yard and the offices of Corus – a complete contrast to how it was in the past, when there was a flourishing community here.

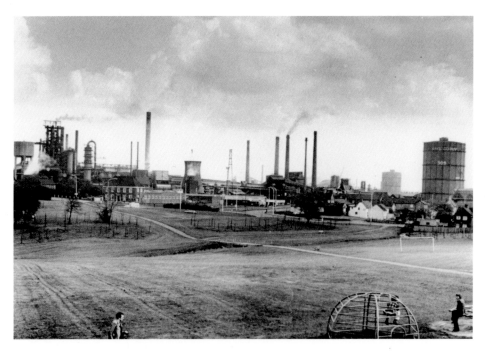

View from Cottingham Bridge, 1960.

Part of the steel works complex can be seen in the background beyond Charter Field. A familiar view for 45 years, all was to change after the closure of the works was announced in 1979. The old post office can be seen far left, with part of the Jamb to the right.

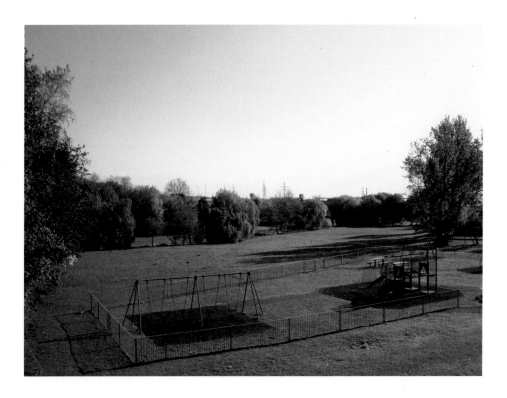

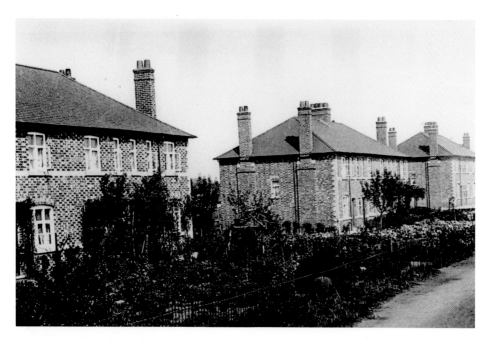

Lloyds Cottages, *c.*1912.

Sixteen cottages were built in 1899 to accommodate the growing workforce at the ironstone works, which was virtually behind the buildings. After being given a protective covering to counter the dampness and pollution, they were known as the Black Houses. Demolition began in 1954, and the present fire station was later built in proximity to the site.

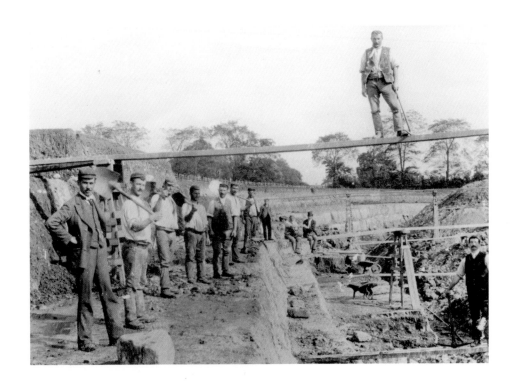

West Glebe quarry, *c.*1909.
This was the third quarry to be worked for ironstone in Corby. Work began in 1897 when a track had been laid and connected to the main railway, and continued until 1916, when the site was abandoned and planted with trees. It became a playground for children, more so after the Parish Council purchased the site in 1938, when it became West Glebe Park.

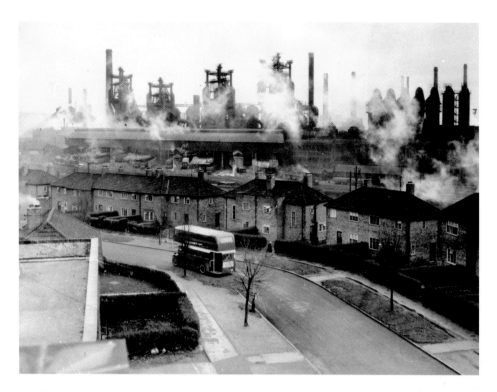

Stephenson Way, 1951.

Taken from the roof of the Odeon cinema, this dramatic scene shows how close some of the housing was to the steelworks. The road, like others in the vicinity, was named after renowned people connected with the industry at some time in history, and was built between 1934-5. Since the closure of the works, the street looks healthier and a better place to live.

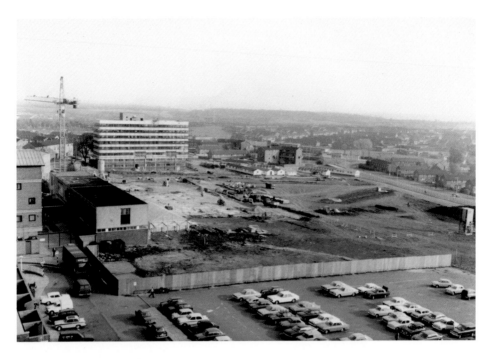

Town centre development.
Incredibly, nearly all the modern development shown here taking place in 1971 has itself since disappeared. Viewed from the vicinity of the new swimming pool, Crown House can be seen in the background. The rest has been replaced by modern stores like TK Maxx and Primark. The new view is taken from the opposite direction.

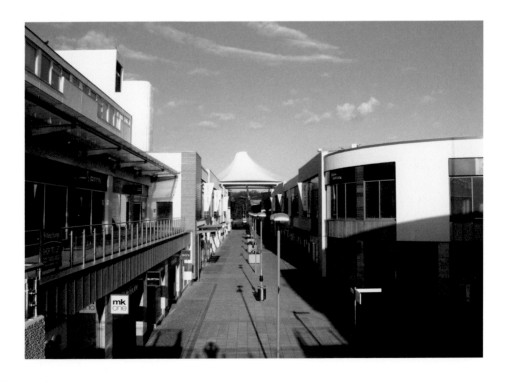

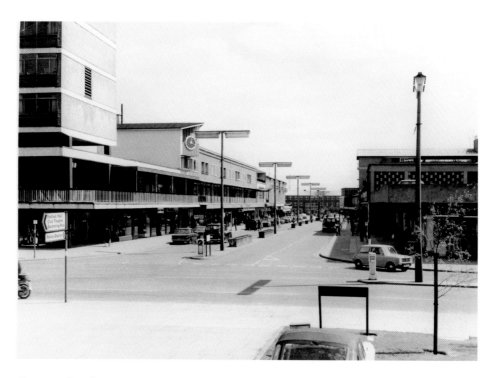

Corporation Street, 1971.

The town centre was officially opened in July 1954 and one of the initial teething problems was the villagers complaining about the shops being too far away and being of a lower standard than their old ones! In 1960, superstition was playing a part – one of nine shops (no.13) on an upper storey had still not been let! This is the street before pedestrianisation in 1974.

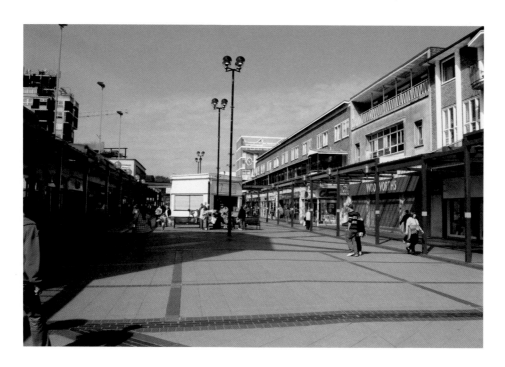

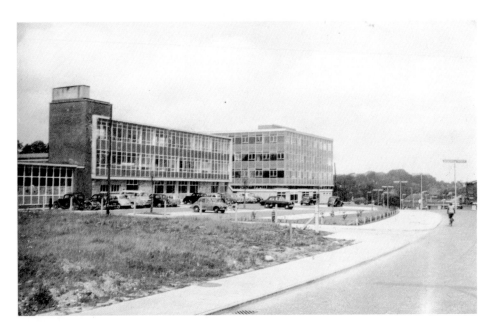

Tresham College, *c*.1962.

Building work began in 1955 at a site in George Street, and was completed in 1958, followed by a second building which opened in 1961. Partly based on the modern Messian style, using industrial steel and plate glass for simplicity and clarity, it was known initially as Corby Technical College, but is now known as the Tresham Institute of Further and Higher Education.

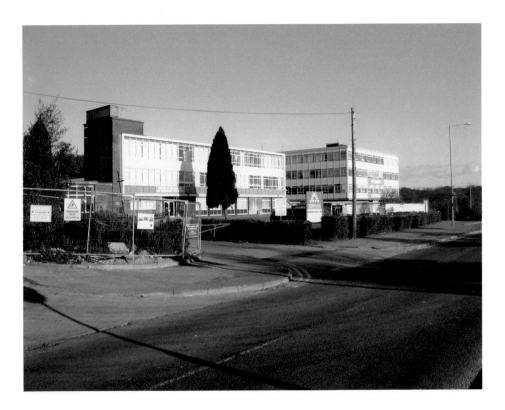

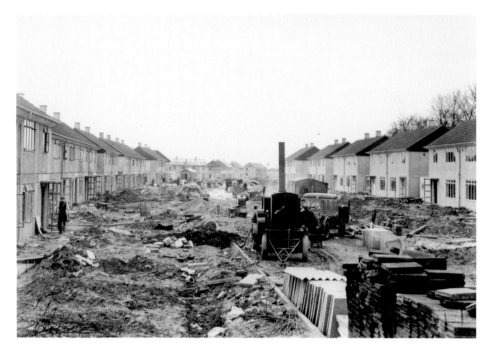

Lodge Park housing development, *c.*1953.

As the population of the town grew following the Second World War, and with designation as a New Town in 1950, so did the demand for even more houses. A vast estate had already been built on a 114 acre site to the north between Rockingham Road and Thoroughsale Woods. Work subsequently began on the Lodge Park estate which was completed in the mid-1950s.

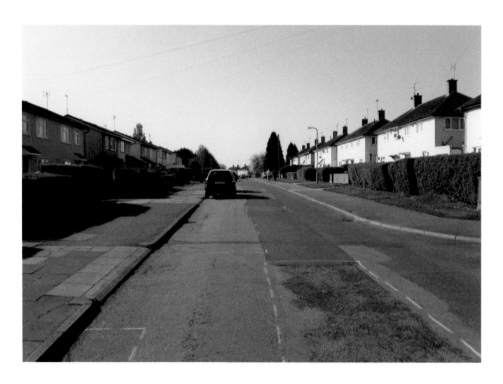

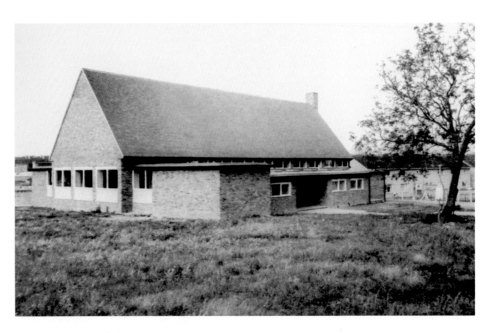

The church of St Peter & St Andrew, 1960.

The two pictures seem entirely unrelated, yet it is the same church. Facing Beanfield Avenue and Newark Drive, it was gutted by a fire started by local boys in 1965. It was rebuilt and enlarged to a futuristic design based on the Triangular Lodge at Rushton, and was reopened in April 1967.

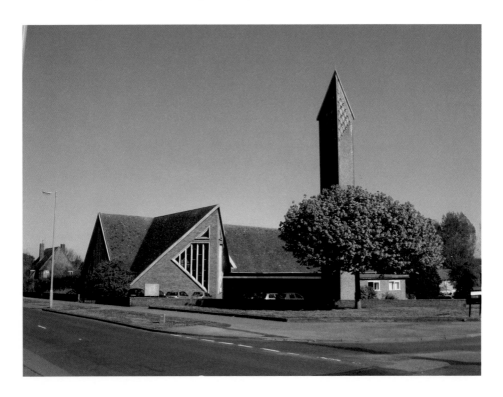

Coldermeadow Lodge, *c.*1959.

This was one of several isolated buildings on the edge of Corby that were soon to disappear. With nearby Keeper's Lodge, it stood on the edge of Kingswood and would be replaced with modern housing, which began on the site in 1960. It stood close to the present secondary school in Gainsborough Road which opened in 1965.

The Corby-Kettering road, Oakley Hay, *c*.1920.
This was the main road to Kettering and Uppingham until 1968, when it was replaced by the present A6014 and A6003. The original road is now overgrown with foliage just before the flyover and traces of it can still be seen in woodland, parallel to the main road, beyond the roundabout. The Spread Eagle in the background was established as a coaching inn in 1753.

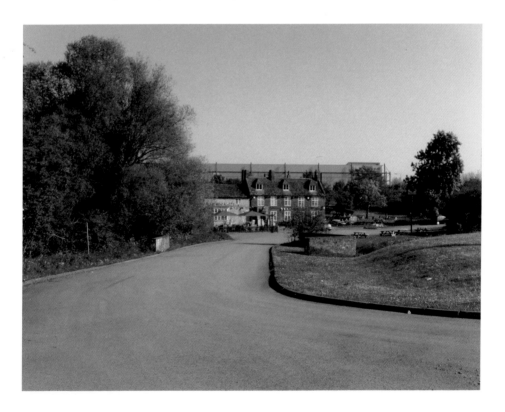

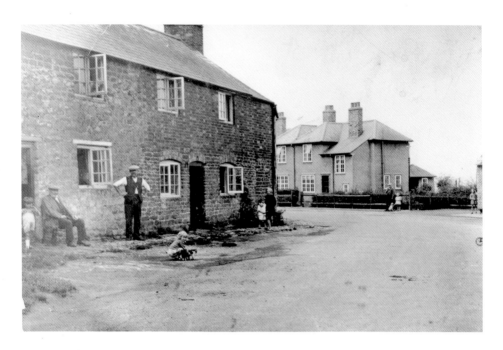

Barton Seagrave, *c.*1930.

An outlying village of the Forest, Barton Seagrave is a shadow of its former self, the original having once been larger, and having a 'castle'. The settlement is partly-named after the medieval lords of the manor. Here we see the edge of the old village, close to the post office, and where much new housing has since been added.

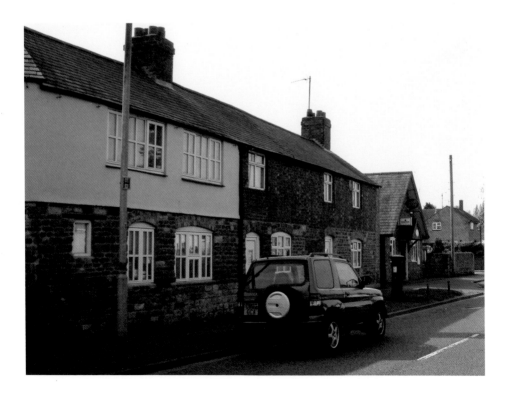

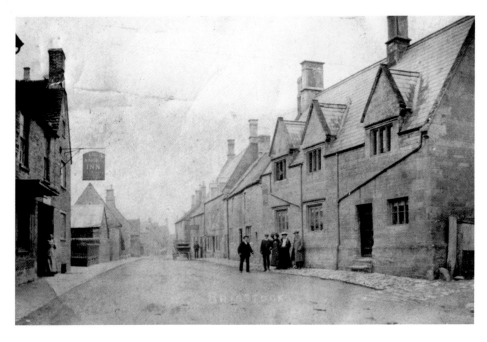

Brigstock: Angel and High Street, *c.*1910.
In the Middle Ages, Brigstock was the largest village in the Forest with a population in excess of 500. This view shows the Angel pub, near the junction with Bridge Street. It was the first of 13 recorded hostelries to close, subsequently becoming a butcher's shop, and is now a private dwelling.

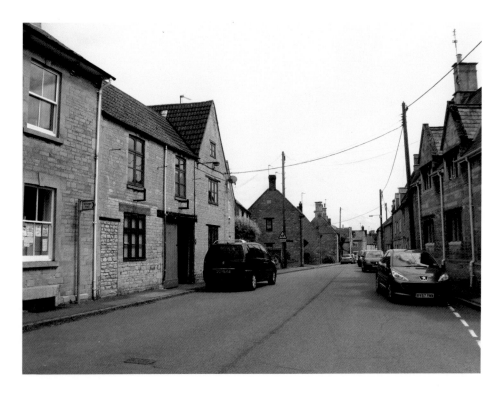

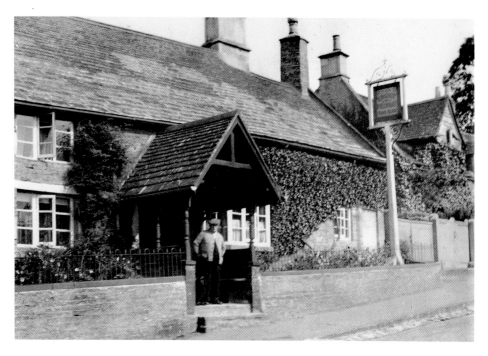

Collyweston: Engine Inn, *c*.1933.

This former hostelry stills stands in the High Street, almost opposite the 'Blue Bell'. Both hostelries like the Corner Inn and the Swan no longer function as such, leaving the Collyweston Slater on the Stamford road, as the only survivor. However, they both still have their original sign posts intact. The publican, Willie Smith, stands at the entrance.

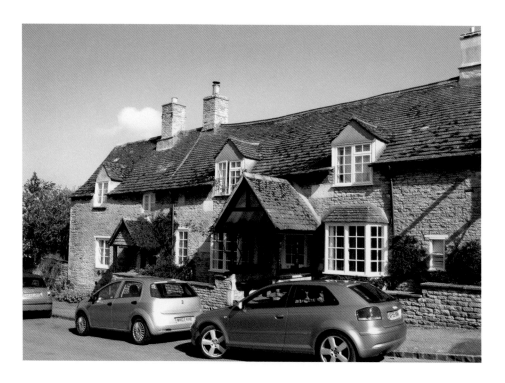

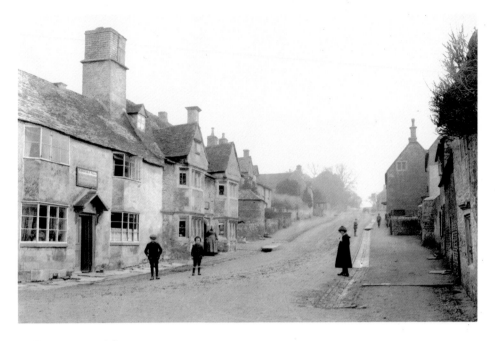

Collyweston: High Street, *c.*1906.

The village street has changed little, except for the drainage on each side now being covered. The former Corner Inn, run by Richard Hill at the time, stands on the immediate left, whilst next door 'The Stewards House', acted as a general grocery shop. The village is nationally renowned for the fine fissile form of limestone used as a roofing material since the Middle Ages.

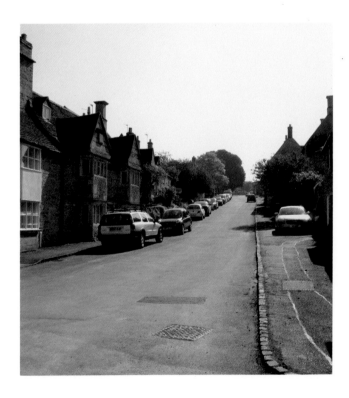

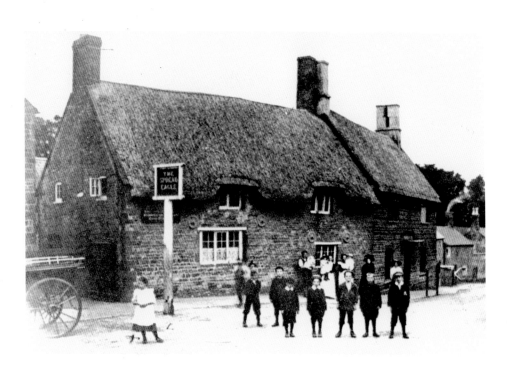

Cottingham: Spread Eagle, *c.*1912.
Rebuilt in the 1960s, this is one of five pubs that once graced the village, and with the Royal George is the only survivor. Its car park on the opposite side of the road was the site of The Crown public house.

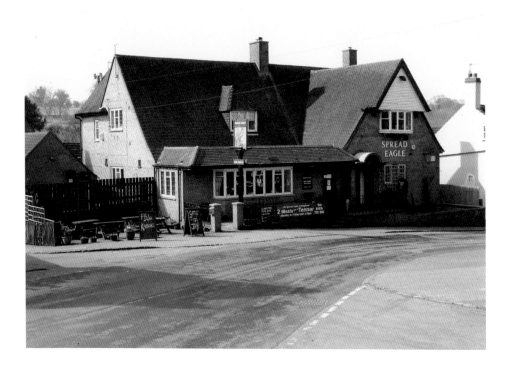

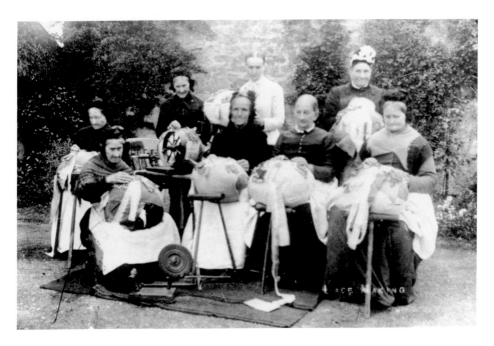

Cranford St Andrew: Lace makers, *c*.1880.

This group of villagers are sitting outside the former rectory (now dwelling), which is tucked away off the Grafton Road. The women are using the traditional method of lacemaking with pillow, bobbins and pins, and would accompany their work with special songs. This was a time when the craft would provide women of all ages with extra income for themselves or their families.

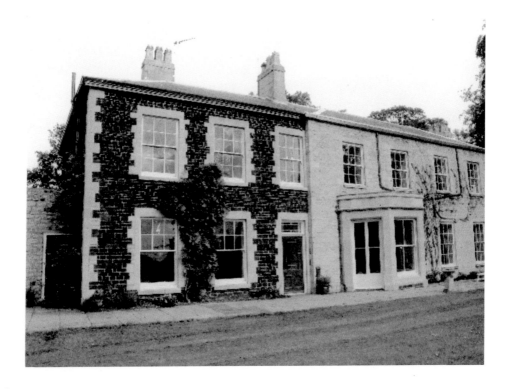

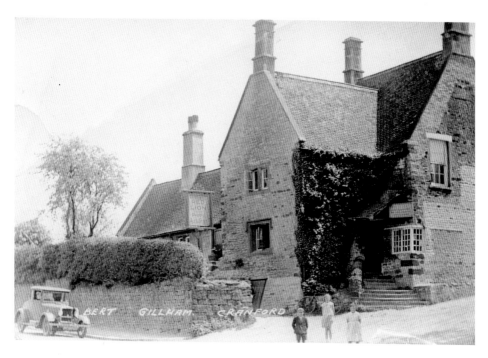

Cranford St John: Red Lion, *c*.1935.

The pub is situated on the main street, which was once the main thoroughfare between Kettering and Thrapston, and since replaced and bypassed by the busy A14. Apart from a brief period of closure, it is still open, being the only survivor of the three hostelries that once existed in the two villages.

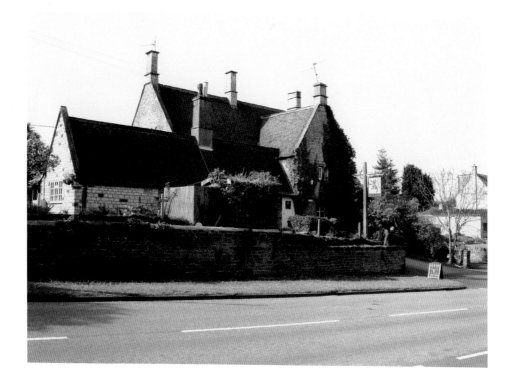

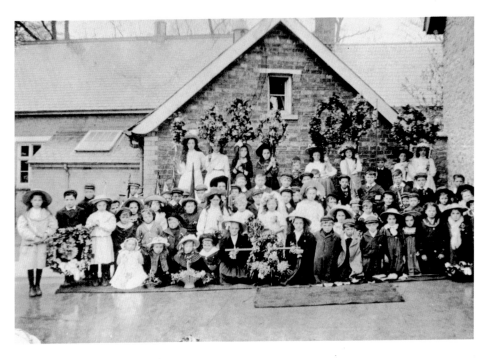

Cranford School, *c.*1905.

Situated in Church Lane at Cranford St John, the school is still active today, albeit with modern additions and alterations. It was originally built in 1857, and restored in 1895 for 112 children. The two views here show the rear of the school.

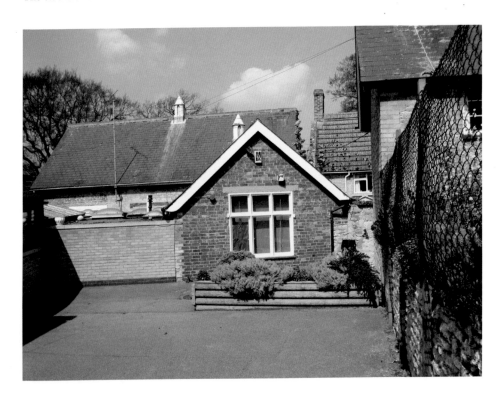

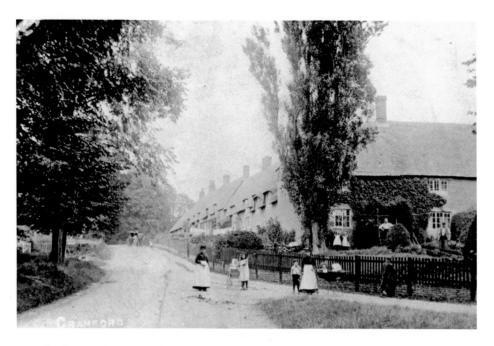

Cranford St Andrew: Grafton Road, *c.*1902.

The row of six thatched cottages along the road date from the early eighteenth century. They all have eyebrow dormers and two have old firemarks still intact. The house in the foreground of what is now St Andrew's Lane is part of a row of three late seventeenth-century cottages, one of which was a former bakehouse; until the 1950s it contained several ovens.

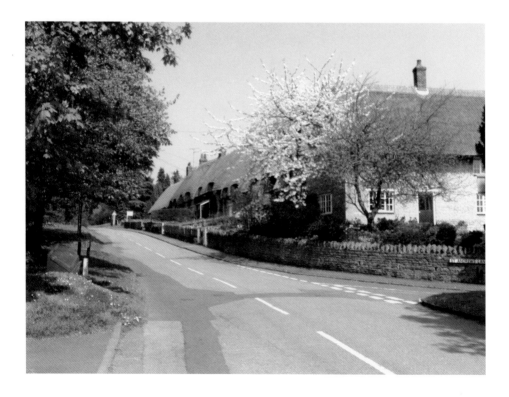

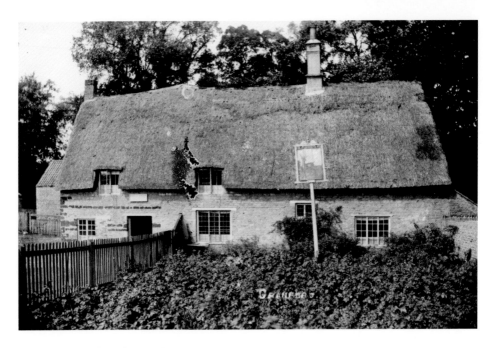

Cranford St John: the Stag, *c.*1870.

The village is divided into two parishes, one each side of a stream. Here in Cranford St John, facing The Green, we see the former hostelry known as the Stag, now two private dwellings. Part limestone, part ironstone, it is of seventeenth-century origin, and sits in peaceful harmony with the surroundings, seemingly having undergone little change.

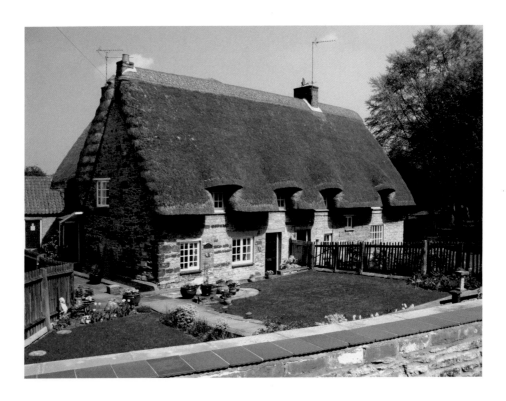

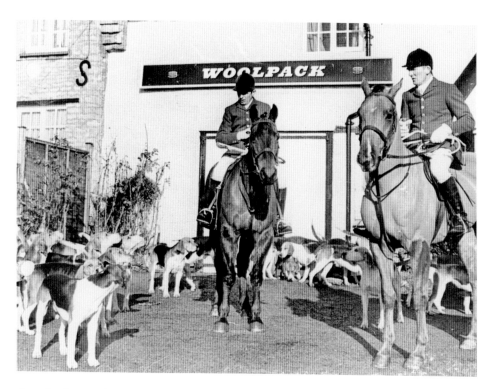

Cranford St Andrew: Woolpack, 1960.

Now a private dwelling, the pub closed in 2000, after serving the village since the eighteenth century, though the building dates from the 1600s. It has a nineteenth-century gabled porch, and a large inglenook fireplace inside, together with a vast collection of brassware.

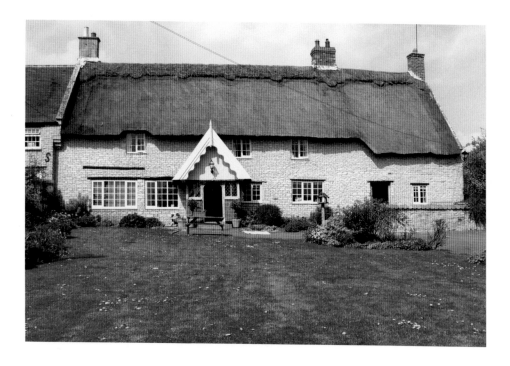

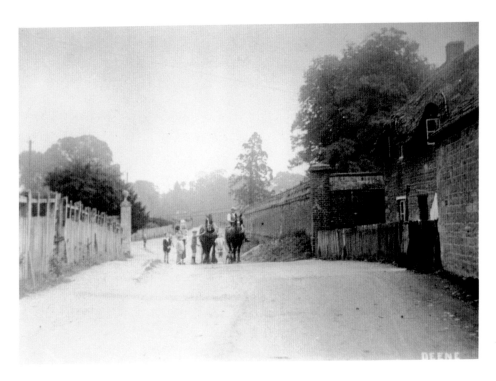

Deene: main street, *c*.1925.

The village is virtually unaltered today, retaining some of its old buildings, like the Blacksmith's Cottage. It no longer has a pub (The Seahorse) but Deene Park, the home of the Brudenell family since 1514, attracts many visitors. In 1854, James Brudenell led the famous Charge of the Light Brigade at Balaclava.

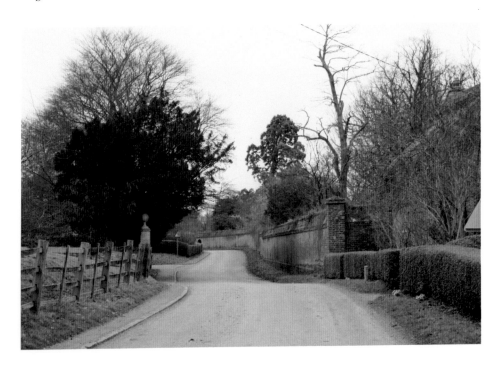

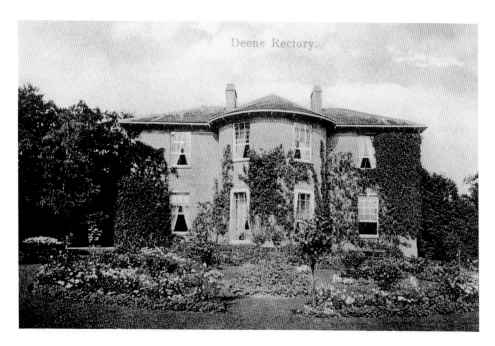

Deene Rectory, *c.1920*.

This fine building stood a little way back from the street leading into the village from what is now the A43. It served the church of St Peter which still survives but is now one of five redundant churches in the Forest. The rectory was built in 1811, and was demolished in 1971.

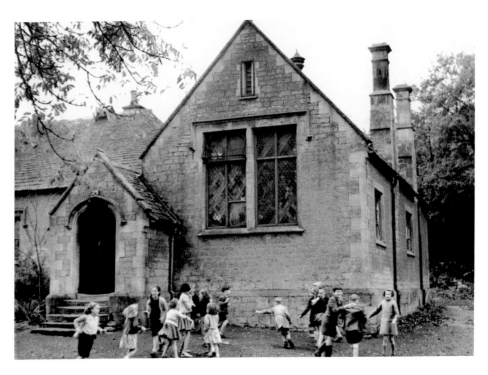

Deene School, *c.*1950.
The school was built by Lady Cardigan (Brudenell) in 1872 for 75 children, who were also given suitable clothing for attendance. It closed in 1954 and is now the village hall.

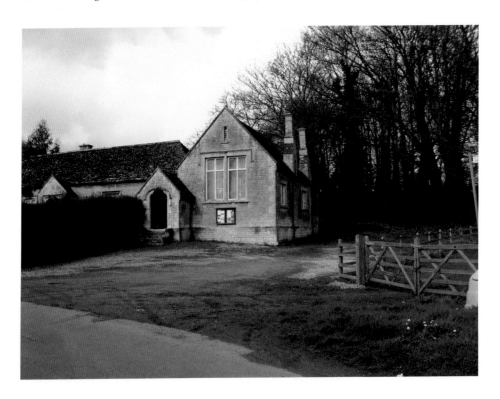

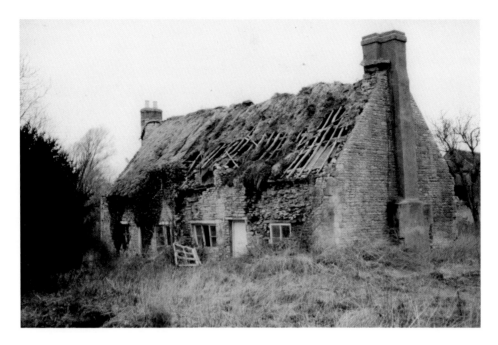

Deenethorpe.

This picture was taken of derelict Candlestick Cottage in 1994. At one time the hamlet far exceeded neighbouring Deene in size of population, with its own school, shop and pub, and with most of the villagers being employed on the Brudenell estate. Since 2000, the settlement has undergone a new lease of life, with some existing buildings such as this one, being rebuilt, and others being constructed nearby.

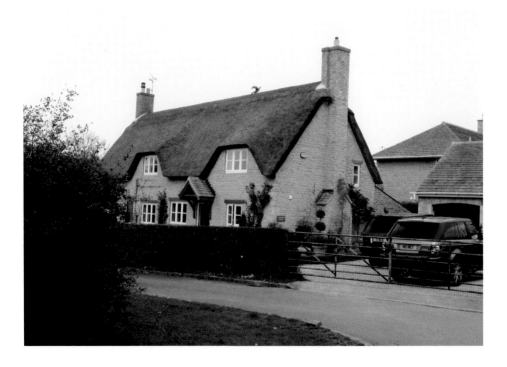

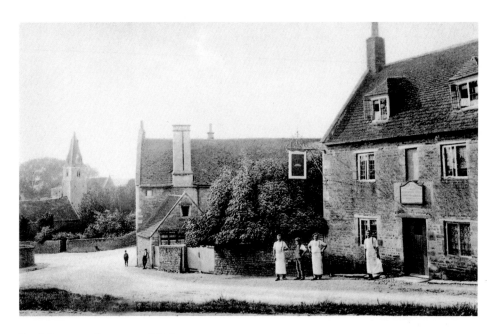

Duddington: Crown, *c.*1896.
The view is from the top of Mill Lane looking towards the church with its unusually-positioned south west tower. The long building in the centre is Stocks Hill House which has ancient Elizabethan decoration on some of its internal walls. The small adjoining building was formerly a shop. Standing outside the Crown public house are the landlord, Thomas Sanders and his staff. The building no longer exists.

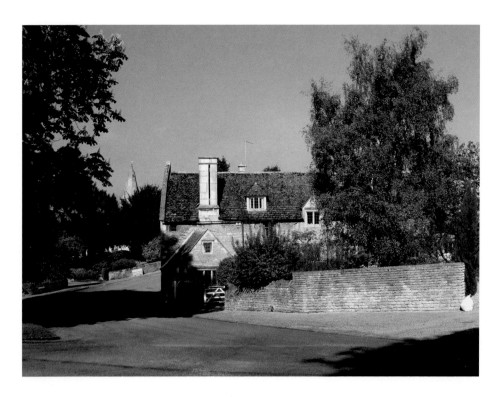

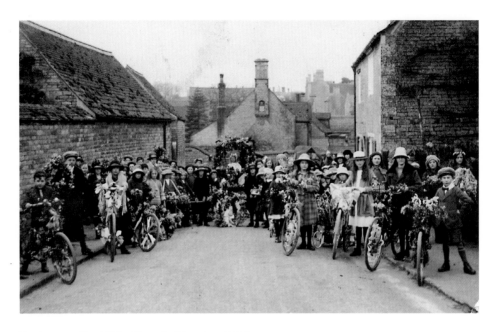

Easton on the Hill: Church Street *c*.1924.

This May Day scene is unique in depicting decorated bicycles, a custom that appeared nationally in the 1890s, usually at village summer feast days and fêtes, when prizes were given for the most attractive floral composition. The May Queen is seated on a mail cart, which is festooned with 'crown imperials', a flower which, like hawthorn, was traditionally used for the occasion.

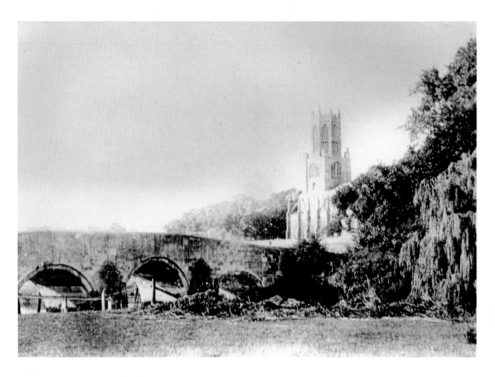

Fotheringhay: the bridge & church, *c.*1900.
A popular visitor attraction in an idyllic setting, the village contains the earthworks of a former castle of the York family where Richard III was born. After the Dissolution in 1538, the church eventually lost its collegiate portion, but is still a magnificent place to visit. The four-arch bridge over the Nene was first recorded in 1498, but the present structure dates from 1722.

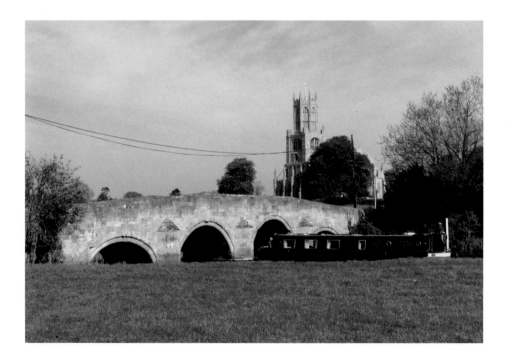

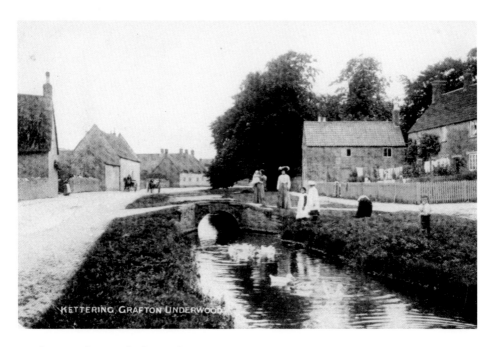

Grafton Underwood: the main street, *c*.1910.

Now a conservation area, the village seems to defy time, with its colonies of ducks, large shady horse chestnut trees, and its small eighteenth-century bridges spanning Alledge Brook, the latter eventually forming part of the parish boundaries of four neighbouring villages, Twywell, Islip, Woodford and Lowick.

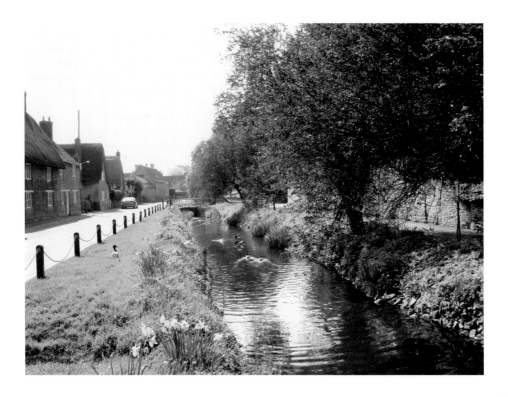

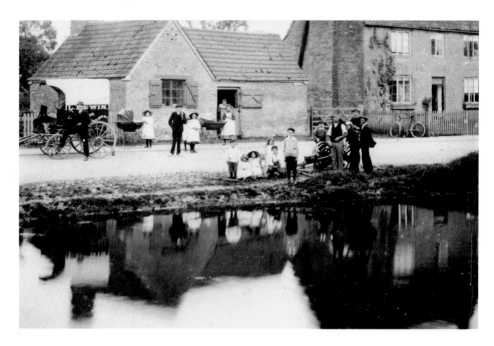

Grafton Underwood: the smithy, *c.*1902.
The blacksmith, George Welton, is standing at the door of his forge which is situated close to the old post office. The man on the left is Lewis Lewin from Kettering, who was a grocer and draper. He was one of several visiting tradesmen who regularly called at the village which itself had two shops at the time, one of which was a bakery.

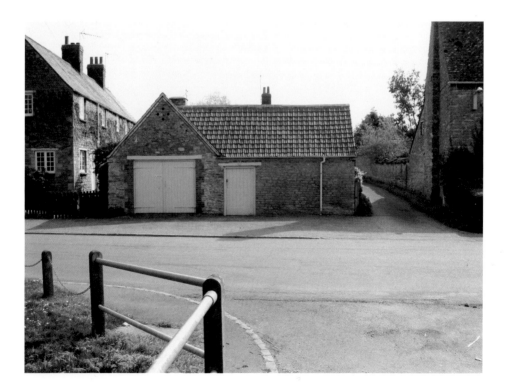

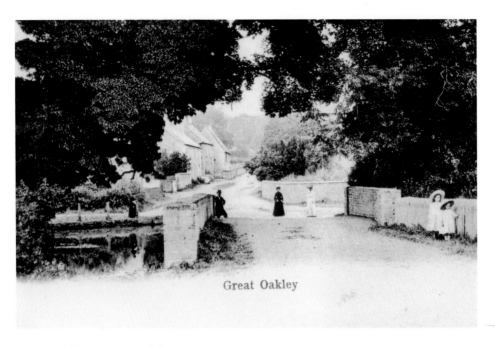

Great Oakley

Great Oakley: 'Duckpaddle', *c.*1900.

The village on this side of Harpers Brook was frequently prone to flooding, and was a favourite haunt of waterfowl, hence the old name for the area. The old bridge was replaced in 1970 and the brook re-dug to alleviate the flooding problems. The trees on each side, one elm and one ash have also disappeared, as has the rectory (out of view).

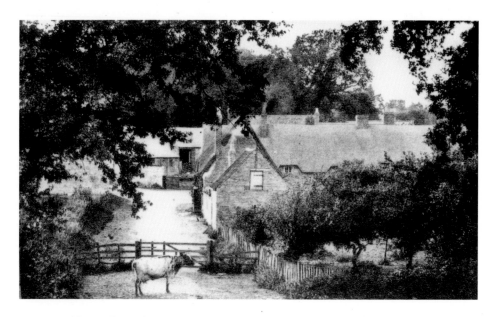

Great Oakley: 'The Other End', *c.*1900.

This part of the village lies over the brook on higher ground, and was known as 'The Other End'. This view is from 'Slab Field', so-called for the set of steps placed up the slope of the field towards the old railway station. A family living in the long thatched building had several children who went on to survive well into their nineties.

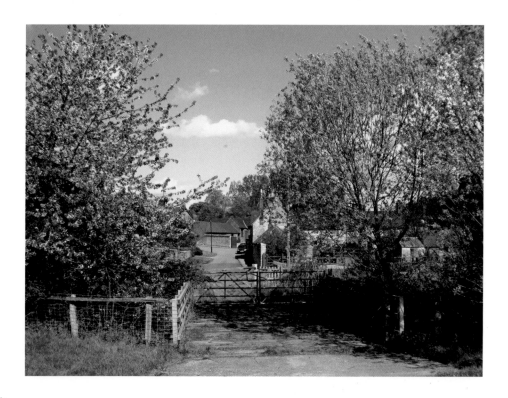

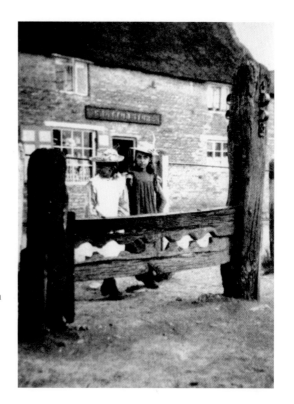

Gretton: the stocks, *c.*1910.
The eighteenth-century stocks and
whipping post still exist on the village
green and were last used in 1858 when
a drunken villager spent six hours
there for refusing to pay a fine. They
form part of a setting that includes
the church, former school, two former
hostelries (the Fox and White Hart),
'Tythe' Farm, and the war memorial.

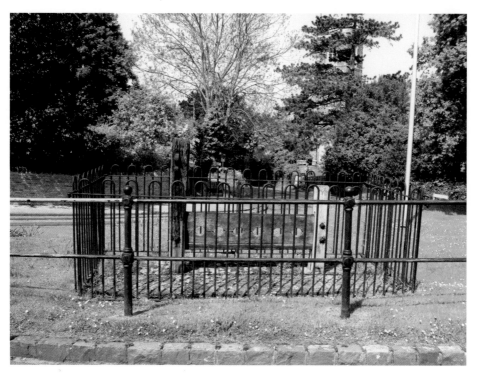

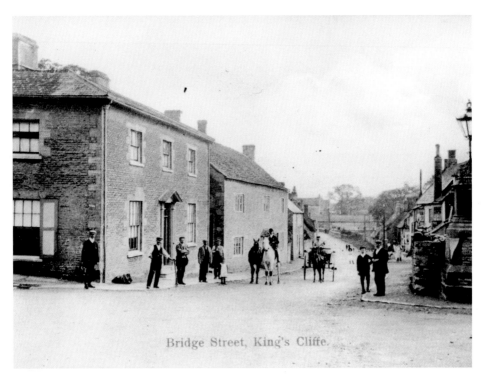

Bridge Street, King's Cliffe.

Kingscliffe: Bridge St, *c.*1906.

This view looks down the street towards the Willow Brook bridge, from outside the Cross Keys pub and the junction with Park Street and Hall Yard. The memorial commemorating Edward VII's coronation can be seen on the right.

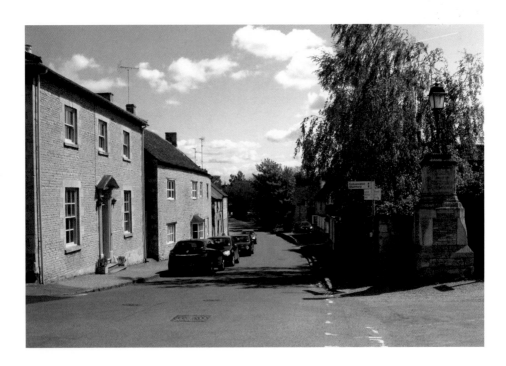

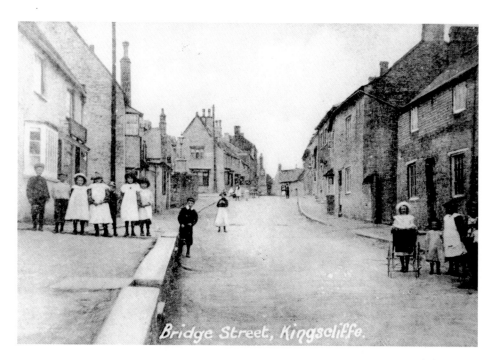

Bridge Street, Kingscliffe.

Kingscliffe: Bridge Street, *c.*1904.

Looking towards West Street, it seems little has changed over the years. The present village shop is the building with its gable facing the road. Virtually the whole village was rebuilt on its present site after a disastrous fire in 1462 destroyed the original settlement which lay behind the church.

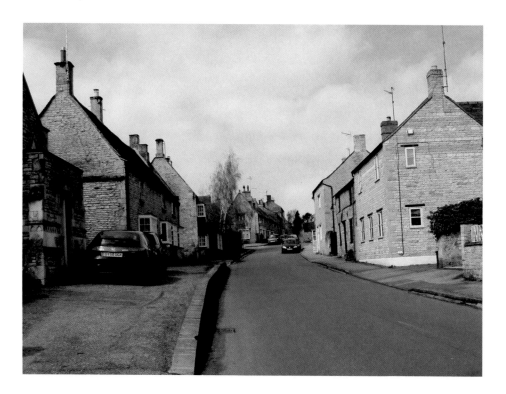

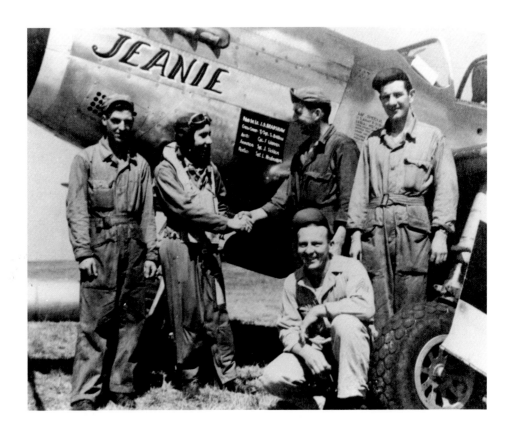

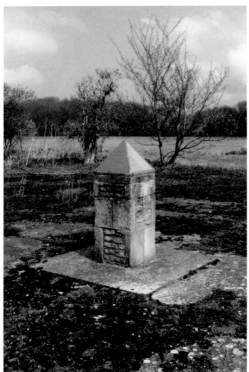

Kingscliffe Airfield.

During the Second World War, the USAAF used the airfield for their fighter aircraft. Some of the local girls later married members of the aircrew, who generously provided crates of oranges when an outbreak of scurvy hit the village. The American bandleader Glenn Miller played one his last dates in England at the aircraft hanger in October 1944, before his disappearance two months later. This memorial marks the spot.

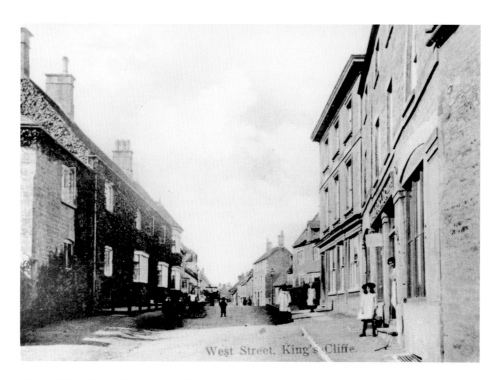

Kingscliffe: West Street, *c.*1906.
This is the busy main street in the village, sections of which were once known under different names. A traditional bakery still flourishes here. In the Middle Ages, the village was the second largest settlement in the Forest with a population averaging 450, and housed one of the main royal hunting lodges in Hall Yard.

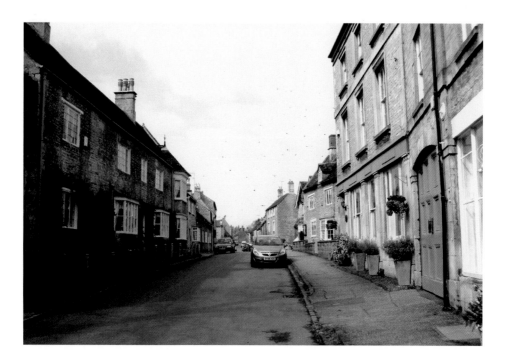

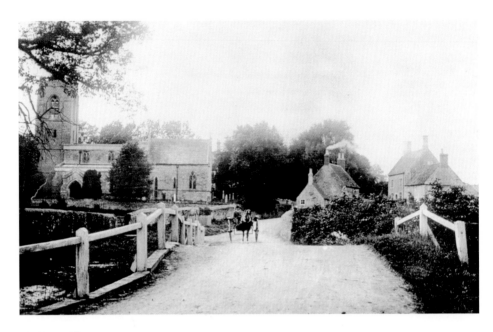

Little Oakley, *c.***1920.**
This is the view as one enters the village from neighbouring Great Oakley. The old bridge has now gone, but sets of worn steps leading down to the water are still visible. It is a favourite haunt of kingfishers and herons. The village is one of only a few where everyone knows and talks to each other!

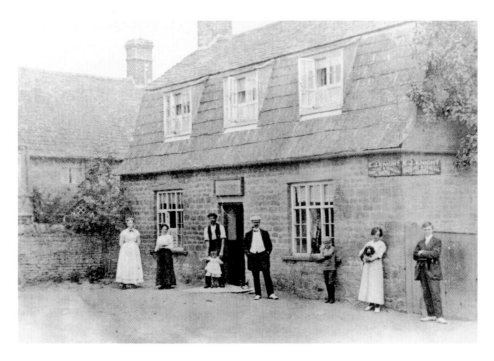

Nassington: Three Horseshoes, 1914.

This was one of several hostelries in the village but no longer trades as such. It was run at the time by Elias Knight, a blacksmith who moved from neighbouring Yarwell. He is seen here in the doorway with his child and relatives.

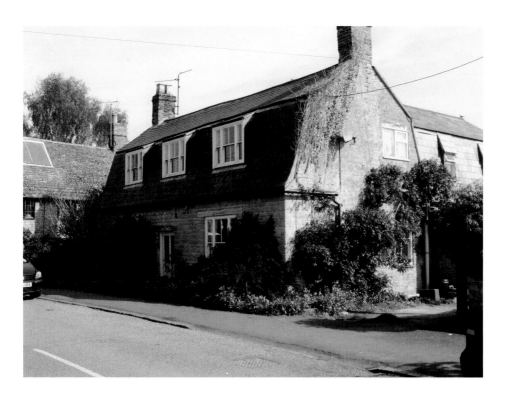

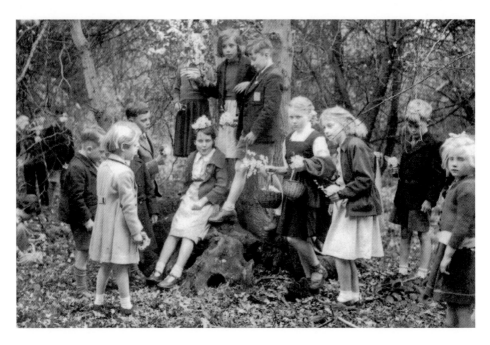

Old Sulehay Woods.

In this ancient part of Rockingham Forest there are many old, strangely-shaped coppiced trees, such as the 'Wishing Tree', with a flat 'seat' from which seven branches protrude upwards. Children from Yarwell School, such as those in this 1956 photo, would place the May garland on one of the branches, and make a wish after calling at homes in the village.

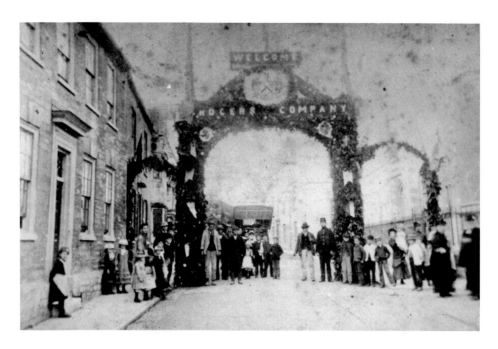

Oundle: New Street, September 1883.

William Laxton, a prosperous merchant, who had become Lord Mayor and Master of the Grocer's Company in London, was responsible in 1556 for the establishment of a grammar school in his home town. It prospered and in September 1883, this triumphal arch was erected, to mark the opening of the new school building, and the beginning of a period of great expansion.

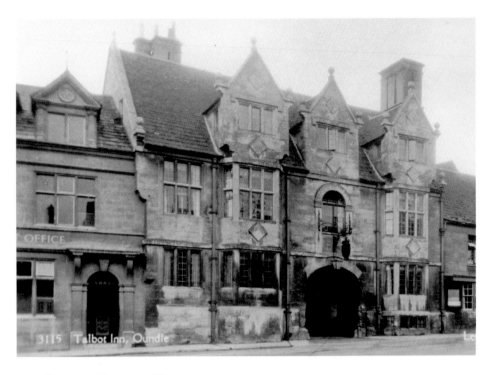

Oundle: Talbot Inn: *c.*1930.

Recorded in 1552, but on the site of an earlier hostelry and formerly known as the Tabret, this is one of only five survivors from a time when over 30 pubs existed in the town. A former coaching inn, it still retains its large courtyard. It was rebuilt in 1626, supposedly with masonry from nearby Fotheringhay Castle where Mary Queen of Scots was executed in 1587.

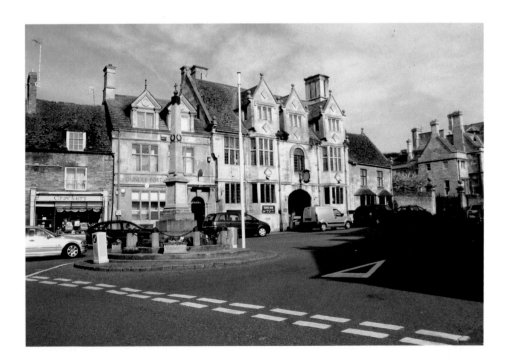

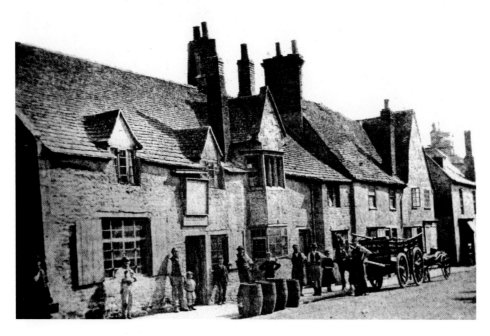

Oundle: White Hart, 1876.

This magnificent building stood opposite three other hostelries in New Street. Everyone in the photo has been recognised, including the bakerman/waggoner. Four years later it was purchased by Oundle School and demolished, like several other structures in the street, for its new buildings.

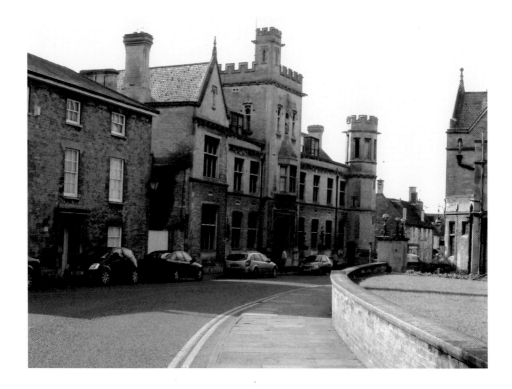

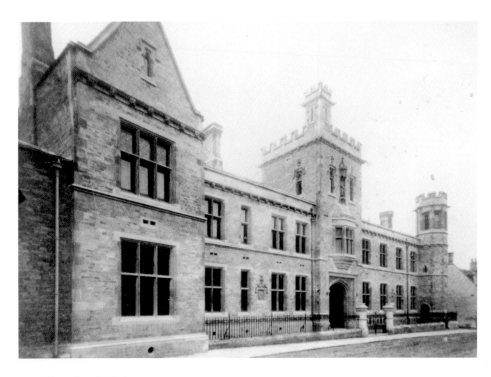

Oundle School Cloisters, *c.*1903.

These were built on the site of the White Hart (in the previous photo), and opened in 1883. The metal railings disappeared during the Second World War, to provide much-needed metal for the manufacture of arms. The modern photo shows the interior of the cloisters as they are today.

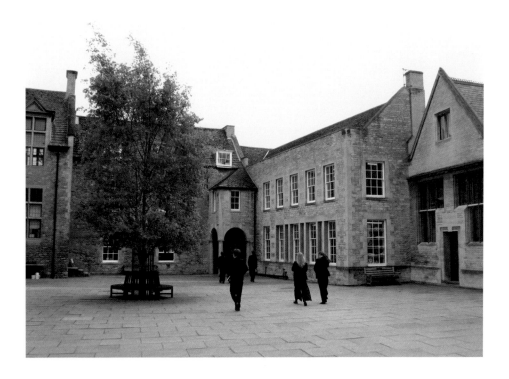

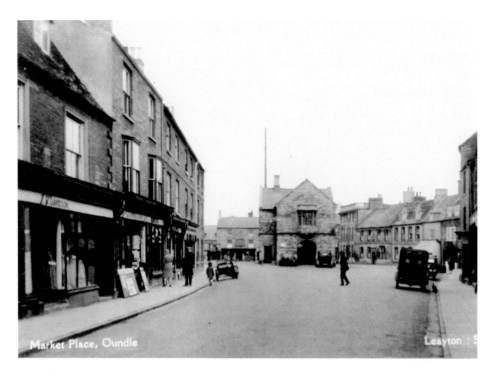

Market Place, Oundle Leayton S

Oundle: West Street, *c.*1928.
This is the main street of the town, and former turnpike road, running from the old market place
to the 'mill end' of the town and beyond. In 1825, the Oundle Improvement Commissioners,
reorganised the old market place, which led to the demolition of existing buildings. The following
year, the Market House/Town Hall, was built, seen here in the centre of the street.

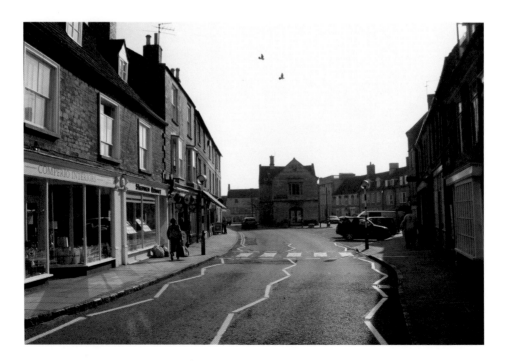

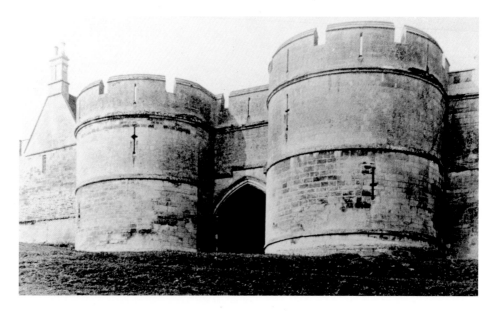

Rockingham Castle, *c.*1930.
Built on the site of a Norman motte and bailey castle, many kings stayed here on hunting trips in the Forest, especially Edward I who modernised and extended the original building, as seen here. Charles Dickens was a regular visitor, staying with his friends Richard and Lavinia Watson, and considered it to be the best country home he had ever seen in England.

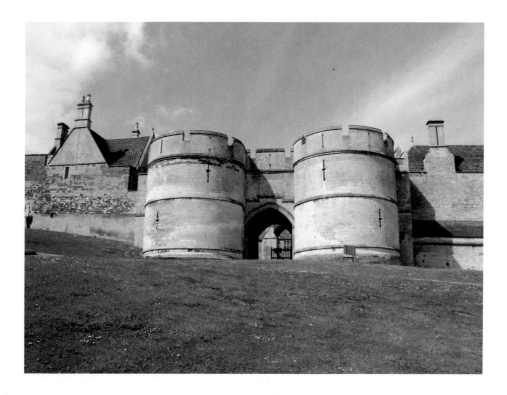

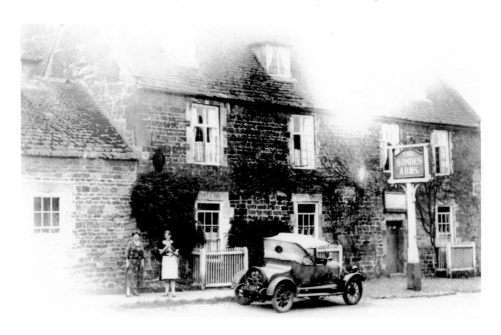

Rockingham: Sondes Arms, 1925.

The landlady, Mrs Hunt, is standing on the left with May Martin who ran a shop in Rockingham Road, Corby, and who later became a Leicestershire beauty queen. When the heir to the castle, Lewis Watson, married Catherine Sondes, in the late seventeenth century, he was subsequently created Viscount Sondes. The pub was then given this name.

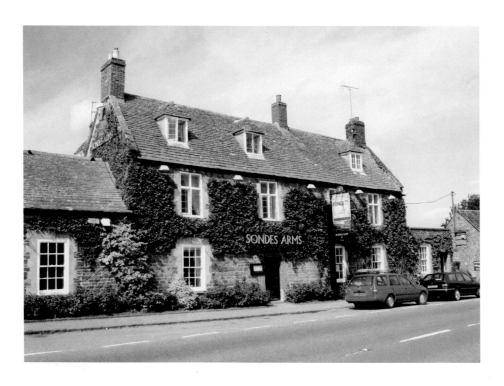

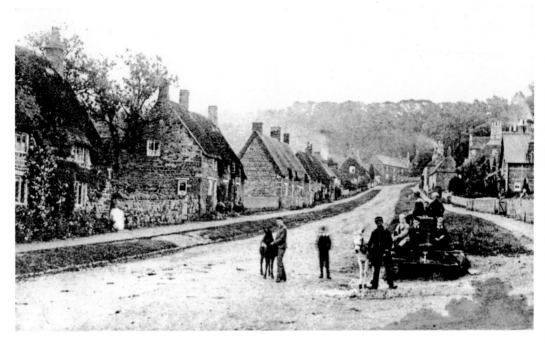

Rockingham: the main street, *c*.1890.

The view is taken from the bottom of the road looking towards the Castle. The boys are sitting on the stump of the medieval market cross. A pillar was added to this four years later in memory of Laura Maria Watson, a member of the family who lived in the castle. Much rebuilding took place along the main street after the ravages of the Civil War.

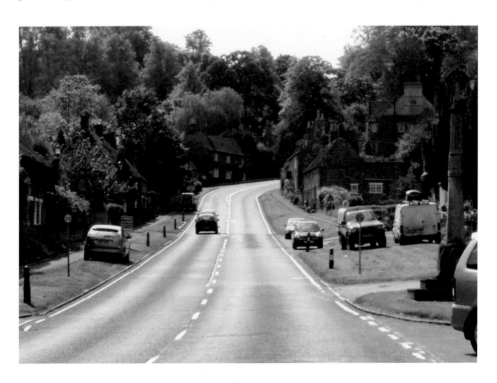

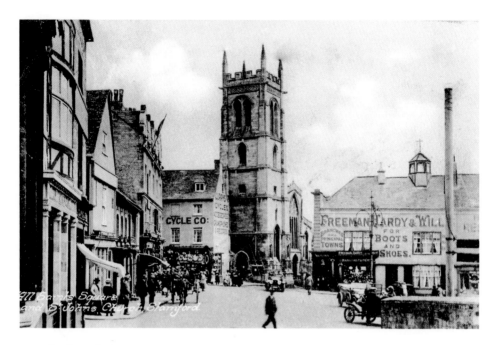

Stamford: Red Lion Square, *c.*1909.

The church of St John appears to be small, but is deceptively large inside. It is one of the five remaining active medieval churches in the town, which once had as many as fourteen. Red Lion Square, named after an inn demolished in the eighteenth century, is at the hub of the town, an extremely busy thoroughfare for traffic going in all directions.

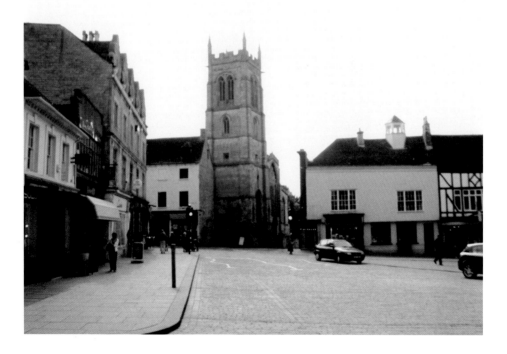

Stamford: St Martin Street, *c.*1930.

Cumberland's grocery store was one of several such shops once serving the town. The premises still trades today, albeit in a different more modern capacity. The street leads away from the town to Burghley House, the home of William Cecil, Chief Minister to Elizabeth I, who is buried in the church of St Martin, a short distance away from this shop.

Stamford:
St Mary's Church, 1905.
This postcard view was taken from outside the old coaching inn, now the George Hotel. The church of St Mary, called 'the mother church of the town' because of its association with the Guild of Corpus Christi and the town corporation, has fine painted and gilded ceilings, one with some ornate images.

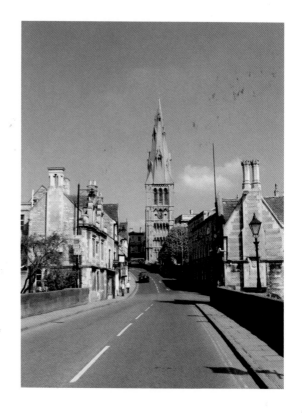

St. Mary's Church. Stamford.

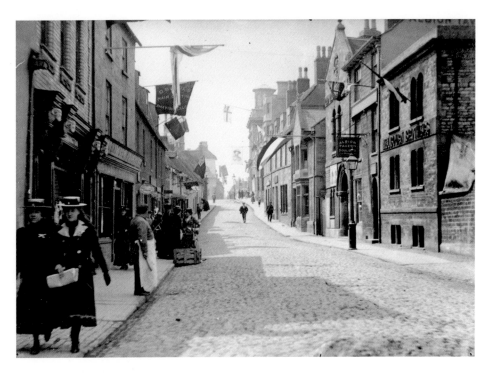

Stamford: All Saints Street, May 1900.

An air of festivity hangs over the street, marking the country's celebrations for the relief of Mafeking in South Africa during the Boer War. The street leads off from Red Lion Square and on the right, is the site of what was a Victorian Steam Brewery, now a modern micro-brewery, which is open to visitors.

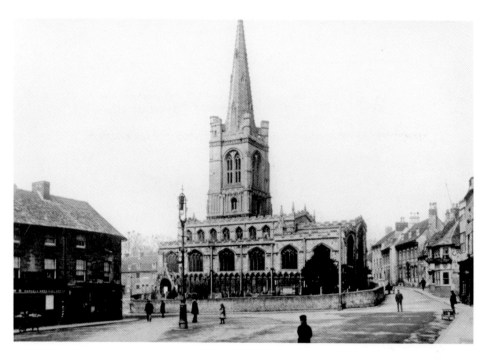

Stamford: All Saints Church, c.1897.

This thirteenth-century church dominates Red Lion Square. One of its most renowned rectors was William Stukeley, the antiquarian, who lived behind the church in Barn Hill. In the nineteenth century, some intrepid folk climbed the spire using the crockets! Barn Hill was also used by the BBC in 1973 as one of the locations in the town for the period drama serial *Middlemarch*.

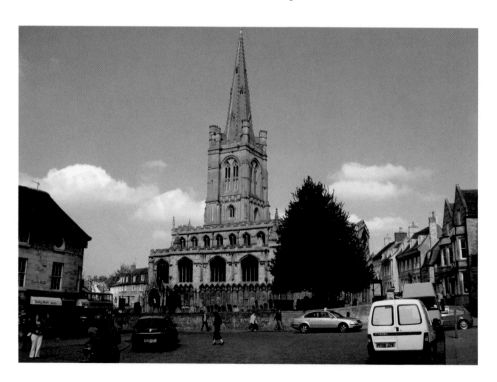

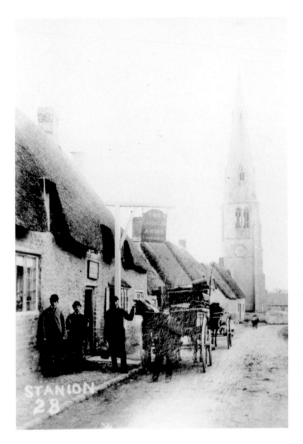

Stanion: High Street, _c._1910.
The Cardigan Arms on the left
has since been rebuilt and set a
little further back. The church of
St Peter has a set of 35 faces on
its walls (said to be villagers living
at the time, though some are quite
grotesque!) and 'the Dun Cow
Rib', supposedly from a legendary
giant cow that once lived in the
village, but in reality a whale bone!

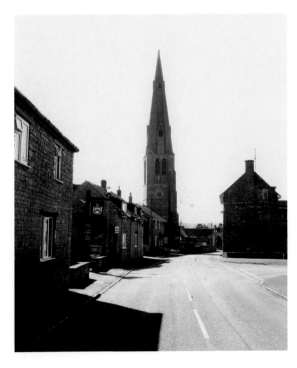

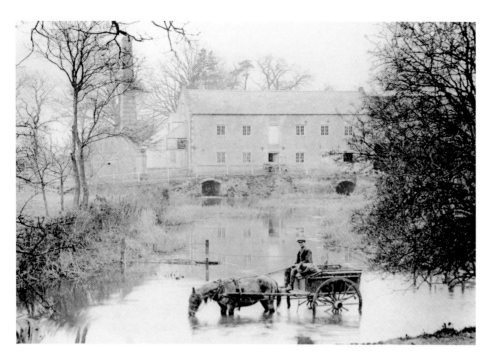

Tinwell Mill, 1886.

Just inside Rutland and close to Stamford, lies the linear village of Tinwell, where the old watermill still stands, though it is now a private residence. In 1887, the year after this photo was taken, an explosion blew the adjacent boiler 50 yards away. Nothing disturbs the air of tranquillity today however, as reflected in this modern view.

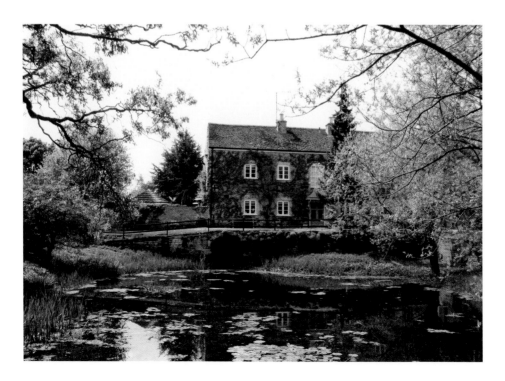

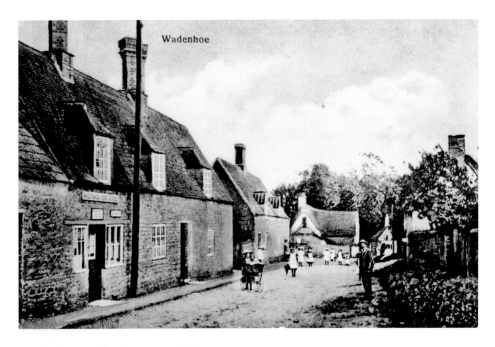

Wadenhoe; Main Street, *c.*1905.

The post office on the left side of the street has long since closed but is said to have acted as the first rural telegraph office when the lord of the manor was George Ward Hunt, Chancellor of the Exchequer and First Lord of the Admiralty in Disraeli's government. Little else has changed and the village is now a conservation area.

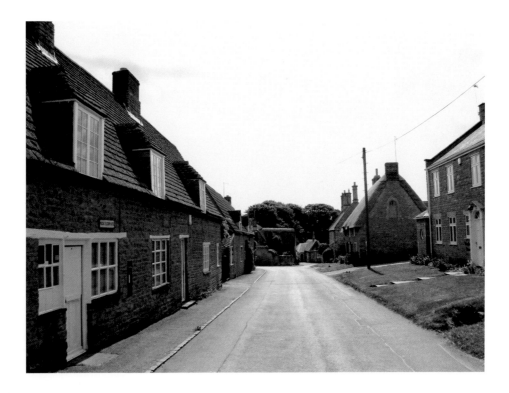

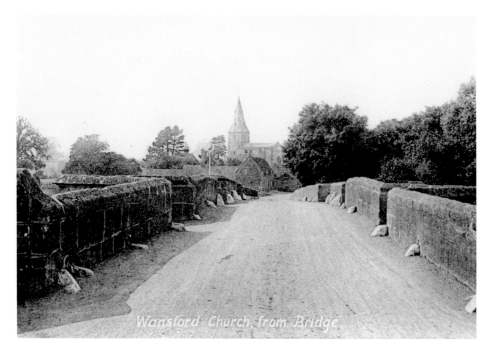

Wansford Church from Bridge

Wansford Bridge, *c.*1900.

This magnificent ancient ten-arch bridge with multiple pedestrian refuges, spanning the Nene, has an inscription 'P M 1577' inscribed on an inner wall. It links the two halves of the village, which were originally in different parishes. This view looks towards the Forest end. The former village mills provided paper for the *Times* newspaper in the 1700s.

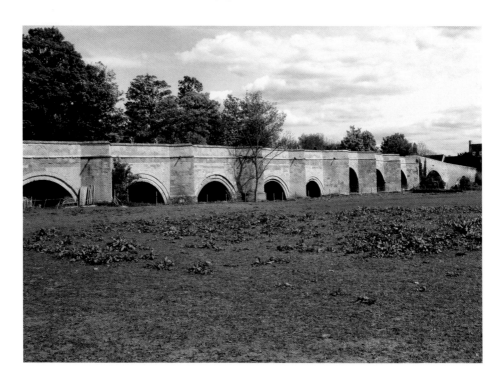

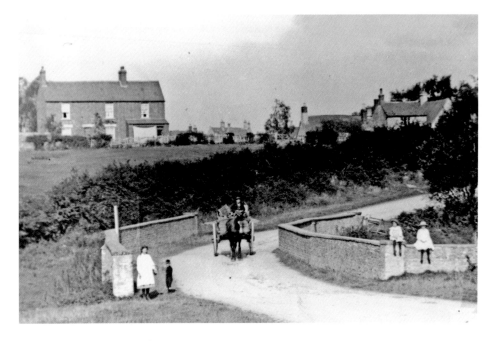

Weldon: Kettering Road, *c.*1905.

The village was originally divided into Little Weldon and Great Weldon. This was Great Weldon, and the earthworks of the original manor house lie in the field to the right. This part of the road was also known as Haunt Hill, after a legend attached to nearby Haunt Hill House, an ornate seventeenth-century stonemason's dwelling.

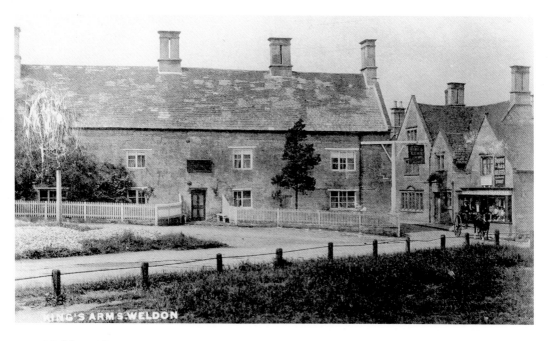

Weldon: Kings Arms, *c.*1920.
Originally known as the Talbot until 1690, this fine coaching inn was demolished in 1962 for road widening, and replaced with a new building set further back. This too was demolished in 2000, and replaced with housing.

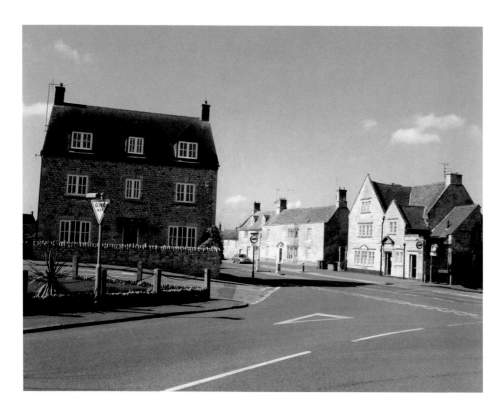

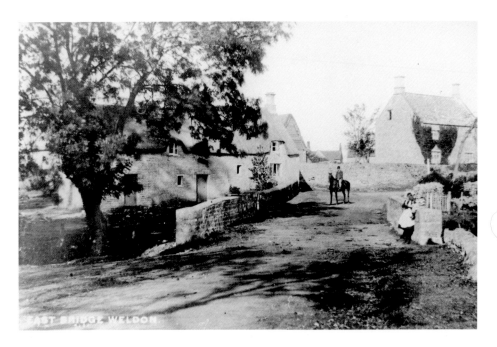

Weldon: Oundle Road, *c*.1905.

Formerly known as East Bridge, this area of the Willow Brook was used as a sheep wash. In the late Tudor period this was Outgange Lane. Church Street leads off to the left, whilst to the right, out of view, is Manor Farm, built in the late sixteenth century by Sir Christopher Hatton to enable a resident steward to oversee his estate.

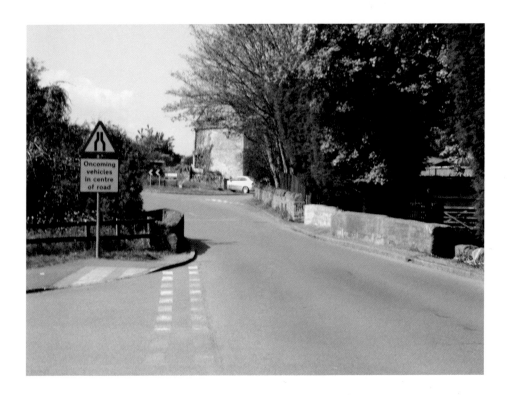

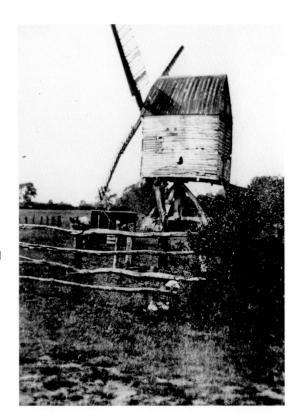

Weldon Windmill, 1916.
The windmill stood in Larratt Road in Little Weldon, close to where the RS Components building stands today. It was a postmill which had been brought over from Wing in Rutland by Corby miller, William Hinckley in 1839. No longer used by the 1890s, it suffered damage during a gale in 1915 and was finally demolished. Allotments now cover the site.

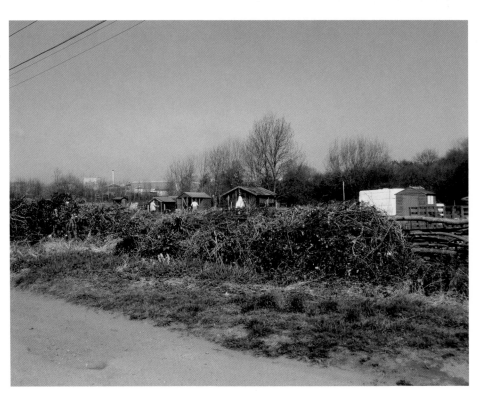

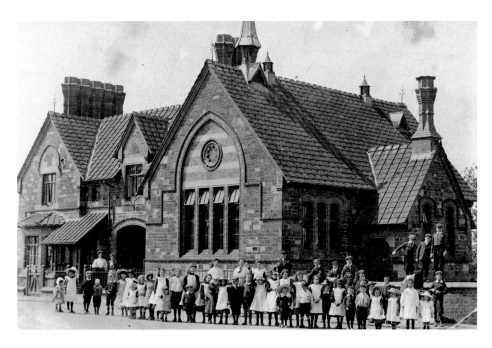

Weston by Welland School, 1910.

This was built, together with a schoolmaster's house in 1871 as a Board School for 75 children from the three villages of Weston, Sutton Basset and Welham (on the other side of the river). It closed in the 1960s and is now a private dwelling. Much of the original fabric has remained, particularly the distinctive multiple chimney stacks.

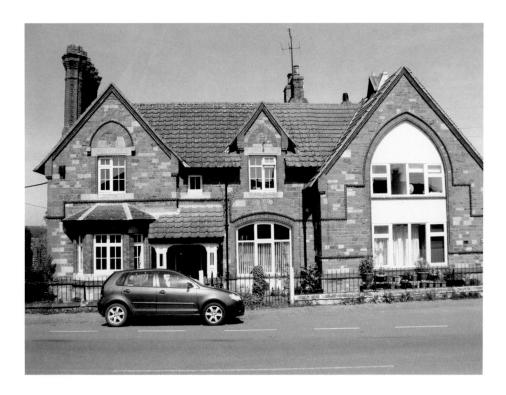

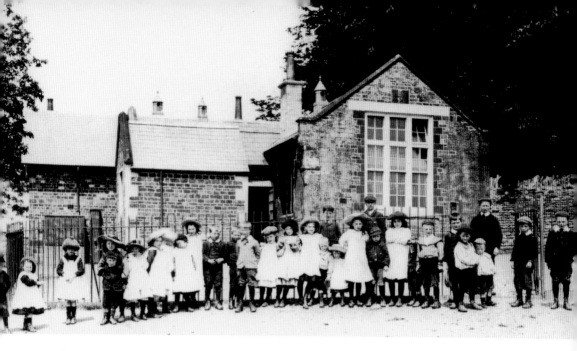

Wilbarston School, *c*.1907.

This was erected 'by subscription' in 1845 for 96 children, and is still active today, although a modern building has since been added and is now the main unit. Interesting features in the vicinity are one surviving wall of a columbarium (dovecote), remnants of a clapper bridge, and the earthworks of a former medieval watermill.

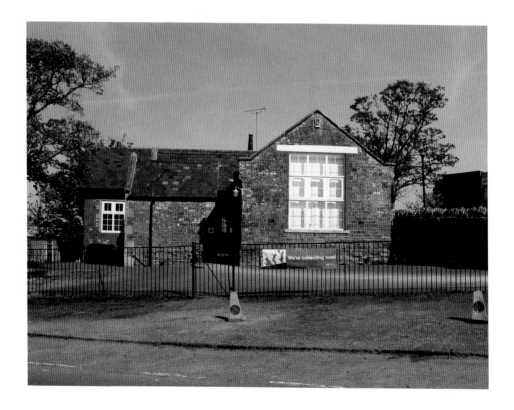

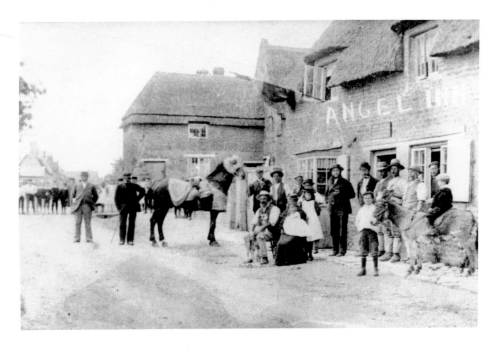

Yarwell: Angel Inn, August 1902.

The villagers are celebrating the coronation of Edward VII. John Allan, the landlord, is not visible among the crowd, but everyone else has been identified, including the decorated Hackney horse! There is also a remarkable range of headwear to be seen. Today's hostelry looks nothing like its predecessor, but the street, despite the number of cars is still relatively quiet.

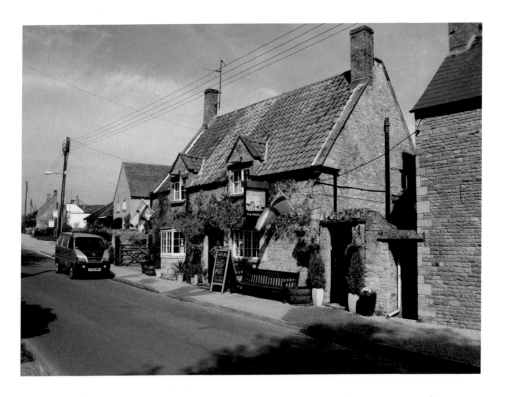

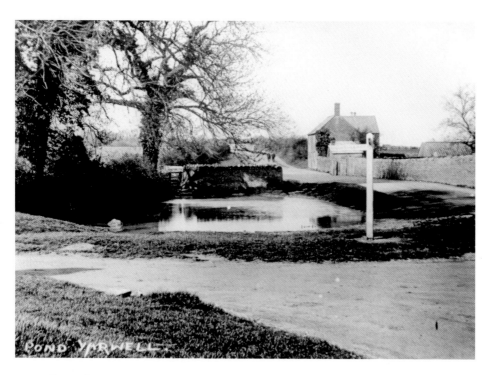

Yarwell Pond, 1910.

This stood at the top of the main street, by the crossroads to Old Sulehay, Nassington and Wansford. It has long been filled in, grassed over, and replaced with a bus shelter and a signboard advertising events at the Angel Inn. However, one of the two old trees is still *in situ*.

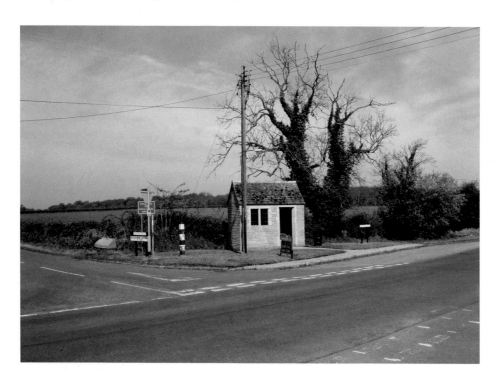

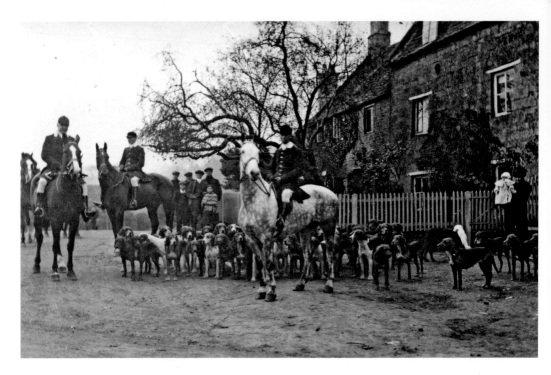

Weldon, from Bridge St.

Since the time of William I, the Forest has been a favourite area for hunting of all kinds, with royal kennels at Brigstock, Rockingham and Weldon. One of the later hunt meeting places was outside the King's Arms. Viewed from the corner of Bridge Street on the opposite side of the road today, the scene is barely recognisable since the demolition of the hostelry.

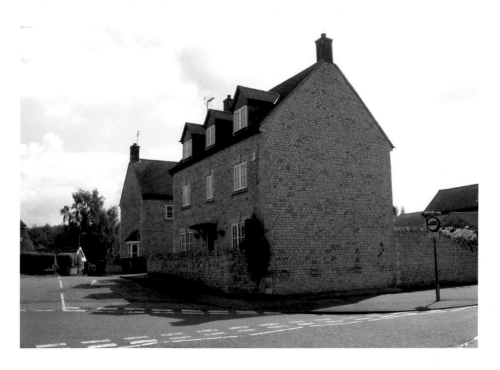